DECORATIVE PAINT FINISHES

FOR THE HOME

WATSON-GUPTILL CRAFTS

DECORATIVE PAINT FINISHES FOR THE HOME

✽

A Complete Guide to Decorative Paint Finishes for Interiors, Furniture, and Accessories

✽

ANDY JONES

WATSON-GUPTILL PUBLICATIONS NEW

This book is dedicated with love and admiration to Priscilla Hauser. Her support and encouragement have provided me with many opportunities that I would have never imagined possible. Thank you, Priscilla, for being my teacher, mentor, and, above all, my friend.

Working on this book has not been a solitary event. Somehow, it has crept into the lives of many people around me, and I want to express my gratitude to them for their support and encouragement: Joyce Beebe, Mary and Michael Belle Isle, Ann Jones, Allison Norwood Thomas, Karen and Richard Toney, Julie Vosberg, Chris Williams, Pat and Ron Worrell.

A special thanks also goes to Phillip Myer, my business and creative partner. Many times his cool demeanor and good common sense have kept me from "reinventing the wheel." His encouragement keeps me moving forward. Thank you.

I would also like to encourage everyone to join the Society of Decorative Painters. This international organization shares the joy of painting throughout the world. The address is: P. O. Box 808, Newton, KS 76114. You are welcome! If you would like to contact me, please write to: PCM Studios, 731 Highland Avenue NE, Suite D, Atlanta, GA 30312.

Copyright © 1996 Andy B. Jones
First published in 1996 in the United States by Watson-Guptill Publications, a division of BPI Communications, Inc., 1515 Broadway, New York, N.Y. 10036.

Library of Congress Cataloging-in-Publication Data

Jones, Andy B.
 Decorative paint finishes for the home : a complete guide to decorative paint finishes for interiors, furniture, and accessories / Andy B. Jones.
 p. cm.
 Includes bibliographical references and index.
 ISBN 0-8230-1281-6 (pbk.)
 1. House painting. 2. Furniture painting. 3. Texture painting. 4. Interior decoration. I. Title.
 TT323.J66 1996
 698'.142—dc20 95-48295
 CIP

All artwork by Andy B. Jones except as noted.
Photography by Tony Foster except as noted.

Printed in Singapore

First printing, 1996
1 2 3 4 5 6 7 8 / 02 01 00 99 98 97 96

Senior Editor: Candace Raney
Developmental Editor: Joy Aquilino
Edited by Alisa Palazzo
Graphic Production by Ellen Greene

NOV − 7 1996

A Word from the Author

By purchasing this book, you have already shown a great interest in interior embellishment. I hope that the information, ideas, techniques, and projects included here will be an inspiration to you and also a guide for your creative efforts.

The techniques in this book are arranged to progress from easy to challenging. While none of the finishes presented here are terribly difficult, please begin with the ones that have an easy skill level. By doing this you are more likely to achieve success and to then be confident enough in your ability to move on and attempt the more advanced techniques. Always work with an open mind and try to keep a positive attitude as you begin each new process. Some of the steps will be more difficult than they first appear; others will be easier than they seem. Never let a minor setback become a stumbling block. Learn from your mistakes; they are your best teachers. With each project that you complete, you will gain skills and confidence.

Now, having cast these pearls of wisdom, it's time to start. Get out that old furniture you've been storing, brush off the cobwebs, and prepare to watch magic happen. It is a very good idea to read through the instructions before you start. You will develop a feel for how the steps flow together, and you will become familiar with what is coming next. Remember that reading is fine, but you have to *do* the techniques in order to truly learn and create. And, after all, what's the worst thing that can happen? You might have to wipe some paint off and start again. The reward is that the changes you can make in everyday objects will astound you and undoubtably be worth your efforts. Even the simplest painted finish can give a room new life. You will soon be transforming every surface around you. I wish you the best as you begin to make beautiful changes in your world.

Andy B. Jones

CONTENTS

Introduction

While painted finishes have recently been enjoying a renaissance in the interior decorating arena, the art of painted finishes is far from new. For centuries people have decorated their surroundings with paint. From the earliest times, primitive man used decoration for beautification and magic. The cave paintings in Lascaux, France, date from 15,000 to 10,000 B.C. and are the earliest evidence of man's need to alter and embellish his surroundings. While the primary reasons for these decorations were practical—to ensure a good hunt and harvest—the beauty of these images remains unchallenged. It is from these humble beginnings that the art of decorative painting has grown and evolved.

The ancient Romans frequently adorned the interiors of their houses with sumptuous wall frescoes, which were often framed by astounding works of *trompe l'oeil* architectural details. Many of these features, such as columns and pedestals, were painted with rich marbleized themes. Even today, the art of these ancient masters inspires awe.

As the interiors became more spectacular, so did the ornamentation. Renaissance churches were also adorned with magnificent frescoes, and altarpieces were covered with gold leaf. This trend toward opulence reached its zenith with royal residences: the palaces of the 17th- and 18th-century French nobility,

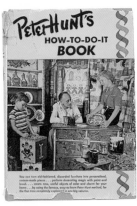

This Dutch Assendelfter box painted by Jacques Zueidema is an elegant example of how decorative painting can enliven simple objects.

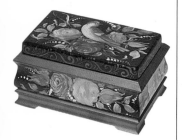

Peter Hunt's first book, Peter Hunt's How To Do It Book *(Prentice-Hall, 1952), teaches his charming style of painting.*

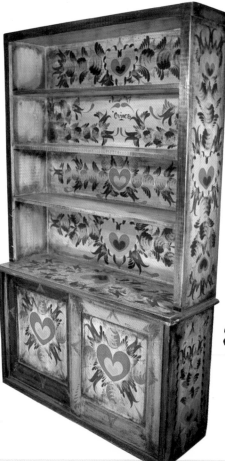

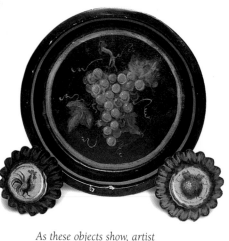

Peter Hunt's unique style is evident in this painted hutch.

As these objects show, artist Peter Ompir was inspired by Peter Hunt's work.

notably that at Versailles, and the various residences of Empress Catherine the Great of Russia (who reigned from 1762 until her death in 1796) are supreme examples of interior painting and gilding.

While most of us will never live in a palace, we can still enjoy decorative painting. In Victorian England, the most popular of the painted finishes was wood graining. At that time, it was more prestigious to have an artist paint your woodwork to resemble an exotic wood, such as mahogany, than it was to have actual mahogany woodwork. And, during the art nouveau and art deco periods of the late 19th and early 20th centuries respectively, painting on furniture and wall ornamentation were again at a high point.

While decorative painting has long been popular in Europe, where artists created enduring art forms that continue to inspire us today, in the United States, creative expression had more humble beginnings. Itinerant artists embellished crude tin- or metalware with lively designs inspired by their homelands of Holland and Germany. (Fractur painting was one such type of early American ornamentation.) Much of the interior painted decoration in the United States was in the form of graining. Artists created fanciful grain patterns on plain pieces of furniture using a variety of glazing materials. The most common style was "vinegar graining," which was achieved with a glaze composed of vinegar or stale beer, some honey or sugar, and powdered pigments. After applying this mixture to a surface, the painter made marks in it with various tools, including corncobs and glaziers putty (the putty that holds window panes in their frames). These pieces are now highly prized by collectors.

Modern decorative painting had a revival in the 1930s when a man named Peter Hunt began to paint and revitalize furniture. His work, which he sold from his studio in Provincetown, Massachusetts, and through department stores such as Marshall Fields, was vivid in coloration, and quaint and witty in style. Hunt worked through the early 1960s and inspired many artists; among them were Peter Ompir, Warner Wrede, and Robert Berger, all of whom were active until the 1980s. Their style of enhancing old household items and transforming them into beautiful accessory pieces is still motivating. Today there are numerous artists and teachers who are willing to share their knowledge and talents to educate and encourage another generation of decorative artists. The Society of Decorative Painters is an organization that you should look into if you are interested in pursuing interior ornamentation or decorative painting.

There are no limits to the wonderful effects that can be created with paints and a few simple tools. You can enliven virtually any surface in your home. Floors, walls, ceilings, furniture, and accessories can all become your canvas.

Metal and wood (here a pot, tray, pail, and clog) are two surfaces you can paint on. These designs are by Robert Berger.

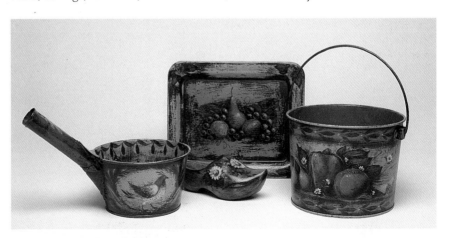

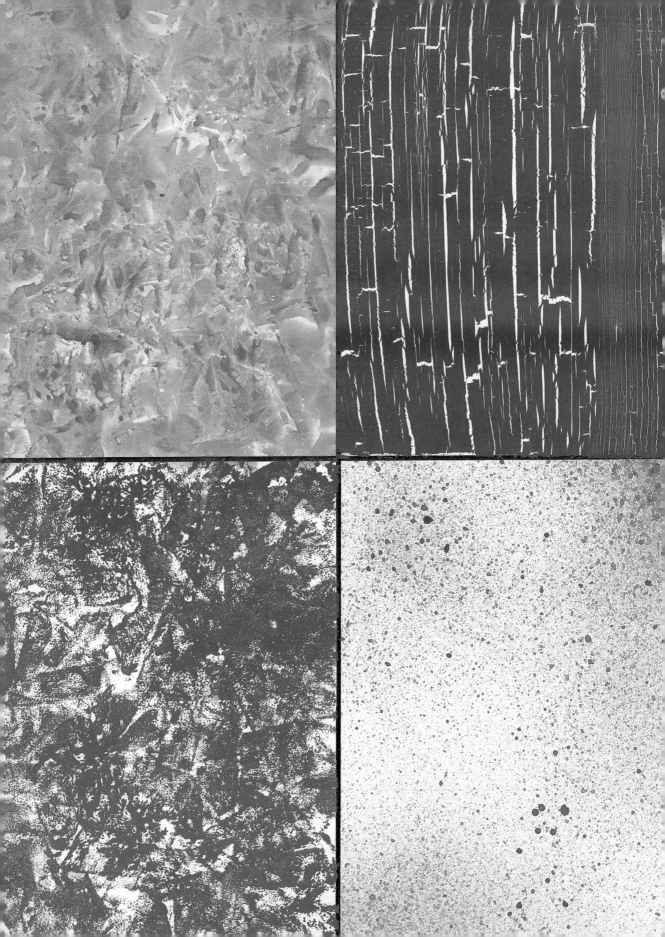

BASIC MATERIALS AND TOOLS

In order to create, you must have the proper means to successfully express yourself. This chapter will familiarize you with the different tools required for applying painted finishes. The materials list presented here will seem vast at first, but not all of these things are necessary for every technique. A separate, more specific listing of materials is included with each project. As you read through this section, you will find that you have many of these supplies already. However, if you have trouble locating some of them, refer to the "Sources" section on page 140 for further assistance.

Paints

You will need a variety of paints to complete the painted finishes in this book. Each type of paint has specific characteristics that will produce certain results. Feel free to experiment with different types of paint. The results that you get may vary greatly depending on which type you use. With these, and all products, please exercise good judgment during use: read the label, follow the manufacturer's instructions, and heed any warnings on the package.

ARTISTS' TUBE ACRYLICS

These are high-quality, heavily pigmented acrylic paints that come in tubes. There are many different brands, but in general, they all have a thick creamy consistency when squeezed from the tube and do not contain many fillers. They are water-soluble, but they dry to an impervious, waterproof film. Tube acrylics are available at most art supply stores and come in a wide range of clear, clean colors, including iridescents, and can be intermixed with other acrylic or latex paints. As with any acrylics, they clean up with water. The colors listed below are those that I frequently use, but you won't need all of them for each project. I prefer Prima brand paints, and these names are all Prima color names. The color names are generally the same for all brands. If you cannot locate the exact same ones, just match them as closely as you can.

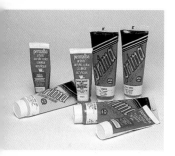

Various brands of tube acrylics.

Ivory black	Turquoise	Iridescent green
Bright red	Ultramarine blue	Metallic gold
Alizarin crimson	Burnt umber	Silver
Titanium white	Iridescent gold	

CRAFT ACRYLICS

Craft acrylics are often called squeeze-bottle (or liquid) acrylics because they are usually packaged in squeezable bottles. They are of a lesser quality than the tube acrylics because they contain less pure pigment and are thinner in consistency. They also often contain a great amount of filler. You can mix craft acrylics with tube acrylics or latex paints. There are many brands available, and they are basically all comparable in quality.

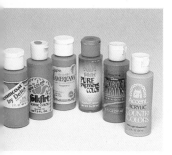

A few different brands of craft acrylics in squeezable bottles.

LATEX PAINTS

Latex paints are water-soluble and made up of pigments, fillers, and binders in an emulsion of latex vinyl. They come in a variety of quality levels, and you should always try to buy the best quality that you can afford. Generally, name brands are better than their bargain counterparts. Often the money saved in buying a cheaper paint is spent in applying many more coats than you normally would; the old adage usually holds true—you get what you pay for. The paints come in gallon and quart containers; the size of your project will determine how much paint you need.

Latex paints are available in a variety of sheens. The *sheen* refers to how dull or shiny the dry paint coating is, with "flat" being the dullest and "gloss" being the shiniest. The complete range from dull to shiny is as follows: flat, eggshell, pearl, satin, semi-gloss, and gloss. However, not all of these sheens are available in all brands of paint.

Latex paints.

Faux Easy water-based glazes.

Various brands of tube oil paints.

I recommend the semi-gloss sheen for most techniques in this book. You will most frequently use latex paints for primary or basecoats under glazes, and the semi-gloss finish creates a slick, sealed surface that will not absorb subsequent glaze applications too quickly. If you use a duller sheen than semi-gloss, you might find that your glazes dry more rapidly, giving you an inadequate amount of time in which to execute your finishes. You will not always need all of the following colors, but these are the ones I use frequently.

Beige (flat)	Off white (semi-gloss)
Black (both semi-gloss and satin)	Red (semi-gloss, gloss)
Ecru (semi-gloss)	Red oxide (semi-gloss)
Light blue (semi-gloss)	Seafoam green (semi-gloss)
Light pink (semi-gloss)	Violet (flat)
Midnight blue (semi-gloss)	Yellow (flat)
Mushroom (semi-gloss)	White (semi-gloss)

WATER-BASED GLAZES

Simply defined, a glaze is a translucent film of a colored medium that is brushed over a surface. When this underlying surface is also colored, the resulting hues are often quite brilliant. The effect is similar to looking through layers of colored glass. (See page 20 for more information on glazes.) I find the Faux Easy brand to be a superior line of water-based glazes. These glazes have a long "open time" that allows you to manipulate them without the fear that they will set up (dry) too quickly. They can also be intermixed to create an endless number of colors. You should have Faux Easy glazes in the following colors on hand, because we will be using them frequently. If you cannot find them, you can mix similar glazes yourself. (See page 23 for glaze recipe.)

Black	Dark brown	Washed denim
Burgundy	Forest green	White
Cranberry	Sunshine	Wine

ARTISTS' TUBE OIL COLORS

Oil paints are one of the oldest mediums used by artists. They are made from pigment mixed with a linseed-oil binder. They are thick and creamy when squeezed from the tube, and you can mix them with mineral spirits or clear painting glaze to thin them to a glaze consistency. Oils can be mixed with one another and also with enamel house paints to create a wide range of colors. They are not water-soluble and require cleanup with mineral spirits (or another solvent). I use Permalba brand in the following colors for many of the projects in this book, but you won't need all these hues all the time. If you can't find this brand, just choose similar colors.

Burnt umber	Sap green
Ivory black	Titanium white

ENAMELS AND ALKYDS

Enamels are made from combinations of varnishes, oil, and pigment and are usually applied in thin, uniform layers. They dry to smooth surfaces with good gloss. Alkyd paints use an oil-modified alkyd resin as a binder instead of linseed oil. Their performance is similar to that of oil paints, but they maintain a bit more flexibility when dry, and they do not yellow. Neither enamels nor alkyds are water-soluble.

Brushes

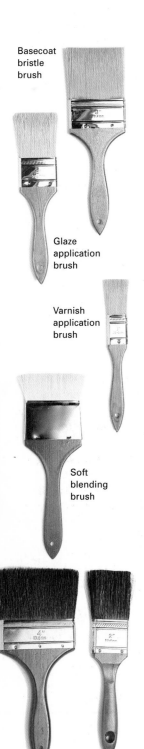

Basecoat bristle brush

Glaze application brush

Varnish application brush

Soft blending brush

House painting brushes

When creating painted finishes, you can make substitutions on many supplies. One notable exception to this, however, is brushes. Your work will only be as good as the brushes you use. Many of the brushes will even make the painting process easier. Some of the techniques that we will discuss require the use of specialty brushes. You can find both standard and specialty brushes in a variety of price ranges. Buy the best quality that you can afford, and you will be rewarded as you work.

BASECOAT BRISTLE BRUSH
This is the workhorse brush. It is a pure hog's-hair bristle brush that is well-constructed (like an artist's brush rather than a lesser quality house painter's brush) and is 3" wide. Its bristles form a good edge and hold a tremendous amount of paint. Use this brush for laying down basecoats or applying glazes to large areas.

GLAZE APPLICATION BRUSH
This brush is made of hog's hair and is 2" wide. It will hold a great deal of glaze. Use it any time you are working with glazes.

VARNISH APPLICATION BRUSH
This is a 1"-wide hog's-hair bristle brush. Use it for all varnish application purposes. Once you have established a brush as your varnishing tool, do not use it for any other purpose. Any paint that might be in a brush could be released during the varnishing process and ruin your finished piece.

SOFT BLENDING BRUSH
This brush is made of goat's hair and is very soft. Because it is designed only for blending previously applied paint (not for applying paint), use it only to lightly dust the paint over the surface. Take care not to allow any paint to dry in the bristle tips. Once this happens, the brush will never perform correctly again.

HOUSE PAINTING BRUSH
The house painting brush is made with hog's hair or nylon bristles. It is available at any paint store and is fine for applying base colors on walls or woodwork. You can use it with enamels or latex paints since it is best suited for house paints, rather than artists' acrylics or oils.

1" SQUARE WASH BRUSH
This 1"-wide brush is made from a blend of natural animal hairs and synthetic fibers. It is ideal for applying glazes, adhesives, or more controlled paint coatings and can be used with a variety of mediums, including acrylics, oils, latex paints, alkyds, and enamels.

FAN BRUSH
The hog's hair bristles in this brush are splayed in a fan shape. For the techniques in this book, choose a large fan with evenly spaced bristles. You can use this brush with oils or acrylics.

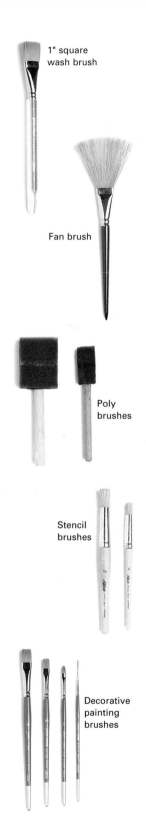

1" square
wash brush

Fan brush

Poly
brushes

Stencil
brushes

Decorative
painting
brushes

POLY BRUSH

This "brush" is composed of a piece of foam attached to a handle. Use it for applying basecoats, trim colors, or gold leaf size and other adhesives. When using this type of brush, be careful that you do not apply too much pressure to the foam because air bubbles will result. Poly brushes are not suitable for use with lacquer-based paints, which will dissolve the foam, but are fine for acrylic, latex, oil, or enamel varieties. (We won't be using any lacquer-based paints in these techniques so you don't really have to worry about this here.) You can either clean them or dispose of them after use.

STENCIL BRUSH

A stencil brush is blunt-tipped and round, and its hog's hair bristles are densely packed into the ferrule (the metal part of the brush that holds the hairs). When selecting a stencil brush, choose one that has a good, smooth end to its bristles; a brush with stray bristles will cause problems when you work.

DECORATIVE PAINTING BRUSHES

These brushes form a good straight, crisp edge and have excellent spring to their bristles. They are also called flat brushes, or flats, and are made from a blend of natural animal hairs and synthetic fibers. You'll need a variety of sizes to complete the decorative designs featured in this book and will find the specific size numbers in the individual technique instructions. Note that I usually refer to them as flat brushes.

CLEANING YOUR BRUSHES

Proper and thorough cleaning of your brushes is essential to extending their life and maintaining the quality of your future work. If you care for your brushes, they will provide years of good service. Allowing paint to dry in a brush even once can cause irreparable damage, so always take the time to clean your brushes after each use.

To clean a brush after using acrylic or latex paints, wash it in warm running water. Pat the bristles against the palm of your hand to flex and release more paint from them. Working a bit of regular dishwashing soap into the bristles can also help loosen and rinse out the color. Pay close attention to removing paint from the area next to the ferrule. This spot often holds a great deal of paint, which, if allowed to dry, will form a hard lump that will cause the bristles to flare out uncontrollably. Once you clean all the paint from the brush, rinse it well to remove any soap. Reshape the brush to its natural point, and allow it to dry. To remove a water-based glaze from a brush, follow this same procedure, but use a product like Murphy's Oil Soap.

Since oils, enamels, and alkyd paints are not water-soluble, you'll need to clean your brushes by first washing them in mineral spirits or paint thinner after using these mediums. This will remove a great deal of the paint. Once you remove most of the color, wipe the brushes on a rag or towel, and wash them in warm running water. Then work a small amount of Murphy's Oil Soap into the bristles to further help remove the paint. Rinse the brushes, and repeat the process with the Murphy's Oil Soap. Your brushes are clean when no more color comes off the bristles as you rinse them. Reshape the brushes, and allow them to dry.

When not in use, let your brushes rest vertically in containers with the bristles up and the handle down. This allows moisture to evaporate from the bristles and preserves the brush's shape.

Miscellaneous Materials

In addition to paints and brushes, there are other supplies that you will need in order to create some of the painted effects in this book. You might already have some of these supplies around the house, and others can be found at local art supply, home improvement, or hardware stores.

MEDIUMS, VARNISHES, AND PRIMERS

Acrylic retarder. You add this medium to acrylic paints and glazes to slow their drying time. Be sure to choose a liquid retarder (not a gel or paste one), because you'll need its thin consistency. I like the Jo Sonja's brand acrylic retarder.

Aging Varnish and Crackle Varnish. This is a two-part liquid crackle varnish product that produces a cracked look. They are two separate products and are sold individually. Lefranc & Bourgeois is a good brand.

Clear Acrylic Spray. Use this to seal fragile surfaces before applying any further paint finishes or varnishes, as in the weathered paint and opaque acrylic antiquing finishes. It is sold in a spray can and comes in both matte and gloss varieties. It can stand alone as a varnish if desired.

Crackle Medium. This produces a crackle finish in freshly dried paint. You can use it over or under decorative design work. Its effect is different from the aging and crackle varnishes and, as you will eventually see, it is used in different crackle techniques than those varnishes. Jo Sonja's is a good brand.

Mineral Spirits. Use this solvent for cleaning brushes, making clear mediums, and thinning oil paints. Use only odorless mineral spirits or paint thinner, because it is not healthy to inhale fumes from traditional thinners such as turpentine.

Primers. Kilz is an excellent all-purpose primer/sealer for use in preparation of surfaces. It is available in both oil- and water-based formulas.

Varnish. You should use top-quality polyurethane varnishes. I recommend Anita's or Varathane brands; these are the only ones I use. They both clean up with water.

TOOLS

Brayer. This rubber roller is used for pressing air bubbles out from under decoupage paper and also to ensure good adhesion when gluing fabric to wood.

Carpenter's Level. This is a tool for determining the levelness of lines. Use it for marking stripes on walls. Purchase one in the longest length you can afford.

Palette Knife. Used for mixing paints and tinting glazes, this implement has a thin, unsharpened blade usually made of steel; choose one with a long, flexible blade.

Roller Paint Applicator. Available in paint and hardware stores, roller paint applicators come in a variety of sizes and naps.

Ruler. You should have a ruler of at least 24" in length.

Ruling Pen. This is a draftsman's tool that you can use for making pinstripes on accessories and furniture. Invest in a professional-quality pen.

Sandpaper. You'll use this for preparing surfaces and for executing some techniques, such as the distressed finish. Stock a variety of grits, from very coarse (#150) to very fine (#400). You might also want to get a *sanding block.* This tool holds a piece of sandpaper, making it easier for you to grasp and manipulate.

Various additional materials including (clockwise from lower left corner) a palette knife, a ruler, a sanding block, foil adhesive, sandpaper, hide glue, crackling varnish, acrylic spray, a sea sponge, thinner, mineral spirits, aging and crackle mediums, feathers, tape, gold leaf, and a brayer.

Spray Mister Bottle. Plastic misting bottles are available from cosmetic supply stores or garden centers. Use them for spritzing surfaces with alcohol or vinegar.

Trowel. This is a tool for applying dry wall joint compound, which is used in the faux-stucco technique.

X-Acto Knife. This versatile knife will allow you to trim tape and, in general, make all sorts of cuts. Number 11 blades should suffice for most cutting needs. Always use fresh blades so that your cuts will be sharp and clean.

GLUES AND ADHESIVES

Foil Adhesive. This is glue for adhering metallic foil to a surface. Do not substitute other glues for this purpose. I use the Backstreet, Inc., brand.

Gold Leaf Size. This oil-based adhesive will produce the best results when you are applying gold leaf. Look for sizing that allows at least four hours of working time before reaching "tack" and drying.

Liquid Hide Glue. Generally available at quality woodworking shops, this is a very strong glue used to adhere fabric to wood and also to achieve some crackle effects. Don't use crystal or dry glue that you prepare yourself. I like Franklin's brand.

Tape. A low-tack (not too sticky), repositionable tape will aid you in marking borders and trims on many pieces. Do not use masking tape or strapping tape as they will pull paint off of the surface. You must make sure that the tape is meant to be used over paint. If in doubt, make a small test patch on an inconspicuous place.

SOAPS AND CLEANSERS

Dishwashing Liquid. Use this basic household soap to clean brushes and to create an acrylic antiquing solution. Dawn or any other brand will do.

Murphy's Oil Soap. You will need this for cleaning your brushes and hands.

OTHER ITEMS

Feathers. You will need feathers for some marbleizing and wood grain techniques. Use only quality turkey or goose feathers that have a nice, fine point.

Liver of Sulfur. This is a liquid oxidizing agent for copper that you'll need for the oxidized copper leaf technique. It is available at craft stores.

Paint Trays. Styrofoam plates with no dividers make excellent trays for mixing glazes or paints. Have a large supply on hand.

Petroleum Jelly. You will need this for the flaking paint technique.

Plastic Wrap. You will use this for several techniques.

Rags. Use only 100% cotton rags. Old T-shirts work really well, but you can also buy cotton rags to use. Prewash them to remove lint.

Salt. You'll need regular table salt for the verdigris technique on copper leaf.

Sea Sponge. This type of sponge makes beautiful organic marks. Do not substitute a foam sponge or a cellulose sponge for a natural sea sponge—the results will not be the same.

Tack cloth. A tack cloth is a piece of cheesecloth that is treated with varnish and oils so that it is sticky. It is handy for removing sawdust from wood.

Vinegar. This is used in the verdigris technique on copper leaf.

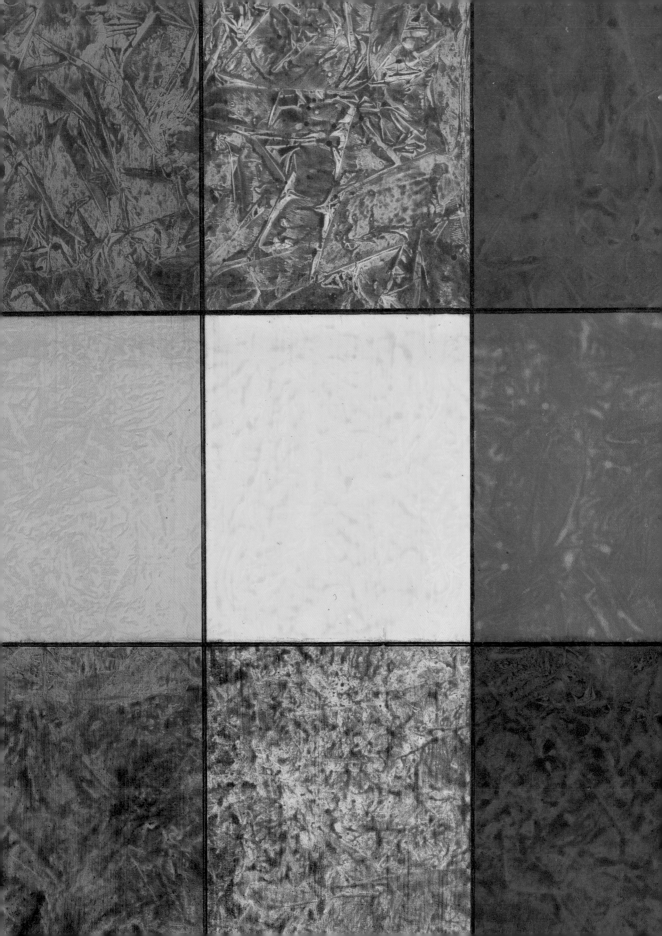

GLAZES
AND COLOR

The creation of most painted finishes requires the use of glazes. A glaze, in its simplest form, is a transparent, fluid film of colored medium that is brushed over a dry surface. Basically, glazing means that rather than mixing two colors together directly to create a third, you instead layer glazes over a surface (or another glaze) separately, treating each layer like a piece of colored glass. The final color is the result of an optical combination rather than a direct physical mixture and the effect is often quite luminous. For a glaze to be effective it must remain workable long enough for you to manipulate it and create a desired result. You can buy commercially prepared glazes, or you can make them yourself from mixtures of various painting products and tailor them to suit your personal needs.

How Glazing Affects Color

Here, you can see how light blue (bottom stripe) and dark blue (top stripe) grounds are altered by two different textured glazes. The dark, transparent glaze covers the left side of both grounds, while the light-colored, semitransparent glaze covers the right. Notice that the dark ground is more affected by the light, semitransparent glaze (top right) and less affected by the transparent dark one (top left). The light ground is less affected by the clouding of the semitransparent glaze (lower right) than the dark ground (top right).

No color stands alone. Every color is affected by light, shadow, and the other colors around it. I would be foolish to try to explain color theory in a few short pages. I will, however, endeavor to explain color theory as it directly relates to painted finishes and to glazing using transparent and semitransparent glazes.

All glazes are semitransparent. This means that some light can pass through them, or that you can see through them. But, some glazes are transparent (meaning that they are even more translucent). So, you might ask, "What is the major difference between a semitransparent and a transparent glaze?" The answer is white colorant. Because of the opaque nature of white pigment, any glaze that contains white cannot be totally transparent; it will be semitransparent. You should keep this in mind as you select colors to use for tinting your glazes. Any commercially prepared oil (enamel and alkyd) or latex house paints will have some white in them. (However, not all artists' acrylic and oil colors have white pigment in them.)

When you apply a transparent glaze over a colored ground, the ground glows through the glaze. The surface is somewhat tinted and altered by the transparent glaze, but the underlying ground is not obscured. The degree to which a ground's appearance is altered by an overlying glaze depends largely on the transparency and color of that glaze. I will discuss the effects of color in glazing later on in this section, but for now I want to concentrate on transparency. In general, if a glaze is very transparent, the underlying ground will be obscured very little (even if the surface color has changed). If the glaze is less transparent, the original ground will be less visible and your resulting surface will, therefore, appear more altered. Depending on its degree of translucence, a semitransparent glaze will cloud the ground it covers to some extent. A light surface will usually be less affected by this clouding than a dark one.

Some simple color theory is needed at this point before we move on to the effect of color on glazes. There are three *primary* colors: red, yellow, and blue. They are known as such because they cannot be mixed from any other colors. The three *secondary* colors are produced by combining two primaries—red plus yellow make orange, red plus blue make violet, and blue plus yellow make green. If you mix a primary with a secondary, you create the *tertiary* colors, of which there are six—red plus orange make red-orange, yellow plus orange make yellow-orange, yellow plus green make yellow-green, blue plus green make blue-green, blue plus violet make blue-violet, and red plus violet make red-violet.

These 12 colors compose the basic artist's color wheel (shown at right). If you familiarize yourself with the placement of these colors on the wheel, you will better understand how colors, and therefore glazes, relate to and work with one another. Two colors that lie directly across from each other on the color wheel are called *complements*. Complementary pairs consist of one primary and one secondary color, such as yellow and violet, or of two tertiary colors, such as yellow-orange and blue-violet. Because of their equal strength, complements intensify each other when placed close together (in a painting or design) and neutralize each other when mixed together. In theory, mixing complements together results in a neutral, gray hue, but oftentimes the end product is an awful, muddy color.

The colors of your grounds and glazes will interact with each other visually. As I stated before, an optical blending of the two layered colors occurs when the transparent glaze is placed over the ground. In essence, you see *both* colors at once,

This example shows how color affects glazing. Pale yellow and blue grounds are seen in their original state in the center stripe. In the top stripe, they are covered with the same transparent, textured yellow glaze It also intensifies the pale yellow. In the bottom stripe, the grounds are coated with a deep green glaze. Note the visual effects.

creating a new color. This resulting hue has more depth, and more of a glow, than a color that is simply mixed on a paint tray and then applied to a surface; a glazed color seems to reflect light, while a mixed one does not.

When choosing colors for glazing, you should opt for hues that work well together and help to create another color. If you place an orange glaze over a blue ground, you will get a murky or muddy result because blue and orange are complementary colors. You will always be safest if you use hues that are within the same color family or that lie close to each other on the color wheel—for example, yellow, yellow-orange, and orange; red, red-violet, and violet; and blue, blue-green, and green. By layering glazes of related hues, you can create great depth of color.

In general when selecting glaze colors, it is helpful to keep the following in mind: light-value glazes will appear less cloudy when placed over light- or medium-value grounds, and dark-value glazes will appear stronger when placed over light-value grounds, as in the example on the previous page.

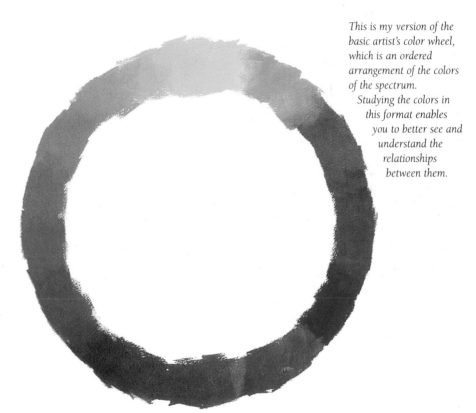

This is my version of the basic artist's color wheel, which is an ordered arrangement of the colors of the spectrum.

Studying the colors in this format enables you to better see and understand the relationships between them.

How to Make Glazes

You can make glazes from either oil-based or water-based products. Each type of glaze, whether oil- or water-based, has unique properties that make it best-suited for one application or another. There are cases in which only one type of glaze will produce the desired results when all others will not.

Today, the coatings industry is moving toward an all water-based line of products. The concerns over the environment and hazardous waste make this change inevitable. Personally, I am comfortable working with both oil- and water-based glazes. If you are sensitive to oil-based products, you can create all of the techniques in this book using solely water-based products. As always, experimentation allows you to become familiar with the working properties of all mediums, and then you can choose which types of glazes work best for you.

OIL-BASED GLAZES

There are many commercially prepared oil-based products on the market. They are available at most paint, decorating, and, possibly, art supply stores. Most of these glazes are clear or whitish in color and are meant to be tinted with enamel house paint or artists' tube oil colors. Each glaze has a different working consistency; some are very thin and fluid, while others are quite thick and jellylike. Each of these glaze products will create different looks, so you might want to test a few of them before you use them.

My personal choice in oil-based glazing mediums, however, is a homemade version. The mixture is similar to a standard oil-painting medium. I refer to this glazing medium throughout the text as "clear, oil-based glazing medium."

MAKING CLEAR, OIL-BASED GLAZING MEDIUM

This recipe (at left) will give satisfactory results for most finishing situations, and the ingredients are available at paint and hardware stores. Each component of the glazing medium performs a specific task: the varnish adds a sticky quality to the medium that allows any texturizing marks to remain as you make them; the linseed oil adds a slickness to the wet glazing medium and increases its open or working time; and the paint thinner dilutes the mixture and makes the pigment more transparent. This clear glazing medium will last for several months if you keep the jar tightly closed.

From time to time you might need to alter the proportions of the ingredients in this recipe when you are working on different projects. For example, if you are ragging a wall, you might want to have a bit more boiled linseed oil in the mixture to give your glaze a slightly softer look and to extend the open time. If you are creating alligator-style texturizing on a small chest, you might want to add a bit more varnish to better hold your marks and help them stay a bit crisper. (See page 32 for ragging techniques and page 40 for alligator-style texturizing.) As I stated before, experimentation is your biggest asset.

Now that you have created a clear glazing medium, you must learn how to tint it with pigment. You can use universal tints or colorants, which come in tubes and are available from most major art supply stores, but this is tricky. It is far easier to use oil-based enamel or alkyd house paints, which you can buy in cans in hardware and house-paint stores. You can also have the store create paints to match any color you desire. (Or, you can use the manufacturer's premixed colors.) Another way to color the glaze is to use artists' tube oil colors.

CLEAR, OIL-BASED GLAZING MEDIUM

1 part oil-based polyurethane varnish

1 part boiled linseed oil (make sure you use the boiled variety)

1 part odorless paint thinner or mineral spirits

Large glass jar

Mixing Instructions. I mix my clear glazing medium in a large glass jar, which I divide into thirds by drawing lines on the outside. Once you pour equal parts of all three ingredients into the jar, simply stir the mixture with a clean stir stick until it is well blended. Try not to shake the jar as this only causes air bubbles to form.

To tint your glazing medium, put a small amount (about two or three tablespoons) of whichever paint you are using into a paint tray. Add about two tablespoons of clear glazing medium, and then mix with a palette knife. Be sure to combine the paint and the glazing medium very thoroughly. If necessary, add some more medium, a small bit at a time, and mix it in again. It is much easier to control the glaze mixture if you add the clear glaze medium in small amounts. It will be impossible to tell whether the glaze is the right level of transparency by looking at it in the tray. You will have to apply a test patch to your surface to determine if it is at the correct level of translucency. If the glaze is too transparent, add some more paint; if it is too opaque, add more clear glazing medium.

Occasionally, you will want the oil-based glaze to dry more rapidly than it normally would. In order to speed the drying time, you must add an oxidizer to the tray of tinted glaze. Japan drier and cobalt siccative are two excellent oxidizers. An oxidizer is a liquid that hastens the drying of oil-based paints by causing a chemical reaction that draws more oxygen to the paint film. Since it is air that causes the solvents in oil paint to evaporate, and thus dries the paint, the addition of an oxidizer accelerates this process. Caution should be used. Only three or four drops will be necessary; using too much of the drier can cause the paint to darken or craze (crackle or shatter). When you become proficient in working with the oil glazes you will always want to add a drop or two of the oxidizer to all your glazes. Note that you should *never* add these driers to your water-based products or glazes.

WATER-BASED GLAZES

With the coatings industry moving toward an all water-based product line, there have been many water-based glazes introduced onto the market. Some are fine, others are not. The problem with most commercially prepared water-based glazing mediums is that they lack sufficient open time to allow you to get adequate results with them.

There is, however, one notable exception to this rule: Anita's brand Faux Easy glazes. They are superb. This is the only brand of commercially prepared glazes that I use. They come in an adequate color range and can be intermixed with one another to create an endless variety of colors. These glazes also make excellent wood stains.

MAKING CLEAR, ACRYLIC GLAZING MEDIUM

In case you cannot find Faux Easy glazes in your area, I am including a recipe for a homemade clear, acrylic glazing medium (at left); all these ingredients should be available at most hardware, paint, and art supply stores. It is important that you use a water-based polyurethane varnish in making this glazing medium. Acrylic or latex vinyl varnishes will not react properly. You must also use a *liquid* acrylic retarder; do *not* use the gel type.

This glazing medium can be tinted with either latex house paints or artists' tube acrylic paints. To do this, put a small amount (two or three tablespoons) of paint onto a paint tray. Add about two tablespoons of glazing medium, and then mix with a palette knife. Be sure to combine the paint and glazing medium very thoroughly. If necessary, add some more medium, a small bit at a time and mix it in again. As with the oil-based version, it is much easier to control the glaze mixture if you add the clear glazing medium in small amounts.

Again, as with the oil-based glaze, it will be impossible to tell whether the glaze is the right level of transparency by looking at it in the tray. You should apply a test patch to your surface to determine if the mixture is at the correct level of translucency. If the glaze is too transparent, add some more paint; if it is too opaque, add more clear glazing medium. The exception to this is the Faux Easy glazes. They are the proper transparency level straight from the container.

CLEAR, ACRYLIC GLAZING MEDIUM

1 part water

1 part water-based polyurethane varnish

1 part liquid acrylic retarder

Large glass jar

Mixing Instructions. Follow the mixing instructions for the oil-based medium on the preceding page.

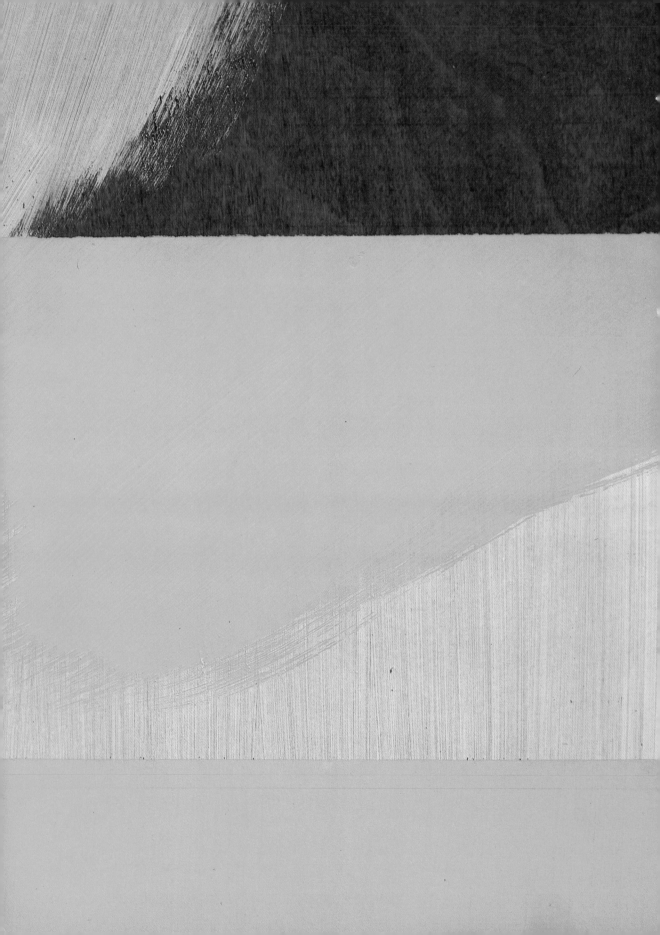

SURFACE PREPARATION

Careful attention must be paid to all aspects of the total project. In order to complete beautiful painted items, you cannot take any shortcuts. Initial preparation of the surface to be decorated is no exception to this rule. Although it is impossible to mention every surface material, I do include preparation instructions for a variety of surfaces. This information should give you a good start.

Wood

Wooden surfaces are wonderful to work on, and they are often the most available surfaces that you will find. You can complete the finishes in this book with ease on virtually any wooden surface, whether it is a new, untreated piece of wood or a junkyard find; you just have to prepare your surface properly.

NEW WOOD

You must properly prepare new, unfinished wood before you begin any decorative design work. While this procedure is tedious, it must be done carefully in order to result in a successful finished project. These instructions apply to accessory pieces, furniture, and any interior woodwork including doors, door frames, window trim, and baseboard and crown molding.

If the wood is new or raw, you must prime it before painting. Brush on a white-pigmented primer coat (primer is available at most hardware or house paint stores); you can use either a water- or oil-based primer. Apply one coat, and allow it to dry. The primer will raise the grain of the wood; the grain will swell and become rough. Next, sand the wood to smooth its surface. Use a #220 grit sandpaper, and then follow with a sanding using #400 sandpaper. This will ensure a nice, clean surface. Wipe the wood with a tack cloth, and apply a second coat of primer. A tack cloth is a specially prepared piece of cheesecloth that is treated with varnish and oils and is very sticky. Use it to remove any sanding residue *each* time you sand your piece. Store it in a small plastic bag inside a baby food jar to prevent it from drying out. When the cloth becomes too soiled or is not sticky, replace it.

For wood that has knot holes or other discolorations, you must use a pigmented (usually white) primer such as Kilz, which is designed to cover knots. Apply an even coat, let it dry, and then sand it after each application. You should repeat the process if necessary. Remember to use the tack cloth after each sanding; the more crumbs you remove, the cleaner and more professional the final results will be. Change your sandpaper after each coat to avoid causing unsightly ridges. Zero in on any bad areas, covering them with a few more coats of primer and sanding after each application. While it might seem a bit overzealous, this kind of meticulous attention to detail will pay off later. There is nothing more disheartening than to complete a lovely piece of furniture and have knot holes showing through a few months, or even years, later.

STRIPPING OLD WOOD

Preparing old wood requires a bit more thought. If the piece has a coat of paint or varnish that is cracking, blistering, or peeling away, you will need to strip the old finish off before proceeding. This is a messy and very time-consuming process and is best left to professionals. If you decide to do it yourself, use a stripper that is made to remove the kind of paint or varnish on the piece. Follow the manufacturer's directions very carefully. Pay attention to times and ventilation suggestions, and always wear rubber gloves. Once you remove all varnish and paint, you can proceed with the preparation process as you would for new, unfinished wood.

If the painted or varnished wood is old but displays no signs of peeling, blistering, or other instability, you need only sand the finish and apply a primer (such as Kilz) as with new, unfinished wood. If the old paint or varnish is adhering well, there is no need to strip the piece.

Sand wooden surfaces well prior to priming or painting, and always sand with the grain of the wood.

Interior Walls

The proper preparation of walls on which you intend to apply paint finishes is a boring but crucial step. If you do this properly, you will be much happier when you complete your painted finish, and your results will be much more professional.

NEW DRYWALL

If you are working on new construction, or on unprimed drywall or Sheetrock, you must first apply a drywall primer, then a paint primer, and then your topcoat.

First, use a primer designed specifically to prime wallboard. This is available at hardware stores. Apply it according to the manufacturer's directions. You will need a quality roller applicator and a house painting brush; using the house painting brush, "cut in" the edges and areas that you cannot reach with the roller. For example, prime the inside corners, and along the baseboard and the edge where the wall meets the ceiling. Then apply the primer to the wall with a roller.

Once you prime the drywall, you need to apply a primer for the paint. It is best to use a primer that is a shade off from your desired topcoat color. This will help you see if you have missed any areas when you put on the topcoats. Apply the primer according to the manufacturer's directions. Again, use a brush to "cut in" the ceiling, corners, and along the baseboards, and a roller for the rest. Always be sure to use a reputable, brand-name primer, and avoid discount or generic-brand products.

When the primer is dry, you will be ready to apply two coats of your desired color (this will be the layer over which you will create your finishes). Again, use a brush to apply the paint along the corners and baseboards, and a roller for the rest. For all of the techniques in this book, I recommend that you use a semi-gloss latex paint. Flat paint is very porous and will absorb any glazes you are using before you can manipulate them on the surface. If your walls are already the color that you wish to work on, but are a flat latex, apply a coat of semi-gloss, water-based polyurethane varnish. The varnish will act as a sealer and also help you manipulate the glaze.

EXISTING CONSTRUCTION

If you are working in a home with walls that are already primed or painted, you will need to begin by surveying the situation. Are the walls full of dings and nail holes? Are there any visible cracks? If either answer is yes, you must make repairs. Remove any artwork from the walls. Remove all picture hooks or nails. Take down any window treatments and drapery hardware. Take off all electrical outlet covers at this point, too. If possible, remove all furniture from the room. If you can't do this, place all of it in the center of the room, and cover it with top-quality drop cloths. Do not skimp on drop-cloth quality.

Fill all nicks, holes, and cracks with a commercial spackling compound, which you can get at any hardware store. If necessary, add a second application to achieve a smooth repair. When the spackling compound is dry, sand it lightly with #220 grit sandpaper. You should not be able to feel the underlying repair. Note that you can't judge this by sight; you have to feel the walls. Don't skimp on this step. Your finished work depends on good preparation.

Once you make all your repairs, proceed as you would for new walls, beginning with the tinted primer and following with two coats of your chosen color. Note that you don't need to use the wall primer here. Use a semi-gloss paint to allow ample working time with your glaze. The preparation for a ceiling would be the same as for walls.

You should fill in any dents or holes in the drywall with lightweight spackling compound using a palette knife.

Other Surfaces

In addition to wood and drywall, there are countless other surfaces to which you can apply painted finishes. I provide here specific directions for preparing some of these other surfaces. Don't be afraid to try the finishes in this book on any surface that you can imagine.

CANVAS FLOORCLOTH

Canvas is generally made of cotton duck and comes in a variety of widths. You purchase it by the foot or yard and can buy it either unprimed, primed, or double primed. Each type has its own advantages. Double-primed canvas is primed on both sides and is a bit stiffer. It can be cut to size and requires no preparation other than a basecoating with your desired background color, which can be oil-based or semi-gloss latex paint. You should carefully work the basecoat color into the edges of the canvas to seal them and prevent unraveling. If you are painting a small floorcloth, choose a double-primed piece of canvas.

Primed (or single-primed) canvas is available in larger sizes than the double-primed type, but you must prime it on the back to help prevent uneven wear. Prime the reverse side with an acrylic artists' gesso (in white), or Kilz primer, basecoat. Work the paint into the fabric with a basecoat bristle brush. This is not a fast process and requires a little elbow grease. You should also turn the edges under and hem them. A professional seamstress or sometimes a shoe repair shop can assist you with this. You will get a neater hem by enlisting the help of a professional. Once the floorcloth is hemmed, proceed with the basecoat in your desired color. It is preferable to use the basecoat bristle brush to apply this coat; you will be able to force the paint into the fibers more easily with a bristle brush than with a sponge brush. Apply a minimum of two coats, but three is preferable.

Unprimed canvas comes in all widths up to 120". This is great for creating very large area rugs that have no seams in them. This unprimed canvas must be hemmed and can be cut into any shape such as circles, ovals, octagons or hexagons, squares, and rectangles. Have the edges turned under and hemmed before priming. Use an oil-based primer on the canvas to prevent the fabric from swelling or stretching due to moisture. It will require two coats on both the front and back. Allow ample drying time between coats. Also, a light sanding and tacking between coats will give you a smoother surface to work on. Once the floorcloth is primed and dry, you can basecoat it in your chosen color as described above.

TIN- AND METALWARE

Tin- or other metalware is an unforgiving surface and requires the utmost care in preparation. New tin pieces usually come with a coating of oil applied by the manufacturer. This is to protect the tin during shipping. You must first remove this surface treatment before you can begin your preparation. Remove the layer of oil by rubbing the piece with a lint-free rag that is saturated with denatured alcohol. Be sure to remove all of the coating—check inside handles, under seams, and in all crevices. Next, wipe with a tack cloth; it is very important to keep the tinware clean (and free of lint and other residue) during all steps of preparation. Now apply a spray metal primer to the tin piece. Metal primers are available in many colors, but I prefer using a flat (rather than glossy), gray hue. Let the spray dry, and then basecoat the piece with enamel, acrylic spray paints, or any basecoat paint that you can brush on. You can use either water-based, oil-based, or latex

paints for this. Be careful to apply any paint in thin layers, as ridges will be much more apparent on tin than on wood or other surfaces. If you choose to spray your basecoat color on, check to be certain that the spray primer and the spray paint products are compatible with one another. If you are unsure, ask; reputable paint stores will be more than happy to assist you.

Old tinware requires a bit more work. If your piece has decoration on it, you should seek the advice of an antique dealer to see if it is of value. To remove decoration, use a commercial paint stripper (available in hardware and paint stores). Use gloves, and work in a well-ventilated area. Outside is the best place to work on this type of piece. If it has any rust, you must remove it or it will return and ruin your work. Remove rust with a commercial rust remover such as naval jelly. (Try your local grocery or hardware store for this.) Follow the directions on the label.

After stripping or using naval jelly, wash the tin piece with a dishwasher detergent such as Cascade (you can use a liquid or make a paste from a powder and water). Be sure to wear rubber gloves as the detergent can irritate your hands. Rinse the piece thoroughly with water. Towel dry it and then immediately place it into a warm, preheated oven. Be sure the oven is *not* hot. You should be able to hold your hand in the oven and feel warmth, but if you have to quickly remove your hand the oven is too hot. Ideally, the oven should be below 200°F, and you should turn it off before putting the tinware in it. If the temperature is too hot you will melt the solder used to construct the piece. Once the tin is dry, remove it from the oven, wipe with a tack cloth, and proceed with priming it with a spray primer, as you would new tinware.

PLASTER AND TERRA-COTTA

This preparation procedure is the same for both plaster and terra-cotta. Begin by washing the piece with a mild dishwashing detergent, like Dawn, and water. This will remove any dirt or grime that might be on the surface. Be sure you allow the piece to dry before you proceed, because any moisture that is trapped in the object will cause problems later.

Once the object is free of dirt and is completely dry, you must prime it. You can use a brush-on or spray-on primer, such as the Kilz brand that I mentioned in the wood sections. You might need to apply two or three coats in order to seal this porous surface. After priming the surface, you can proceed to apply your chosen basecoat color. Again, you can either brush or spray on this color.

Make sure you clean your metalware properly to ensure that your paint finishes will withstand the effects of time and handling. New tinware is protected with an oily coating, which you must remove (as I do here) prior to priming and basecoating.

TEXTURED FINISHES

The various ragging and texturizing finishes are all uncomplicated techniques that can add interest to any surface. With the use of simple tools and ingredients, such as rags, plastic wrap, and glazes, you can create soft, abstract textures on any item. If you prefer a look that is less subtle, you can use bright, rich colors and really make a strong design statement.

Positive Ragging

MATERIALS

Paints
Mushroom semi-gloss
latex paint

Glazes
Butter cream water-based
glaze

Brushes
Basecoat bristle brush

Miscellaneous
Paint trays
Cotton rags

Positive ragging is one of the easiest ragging techniques. It gets its name from the glaze application tool: a rag. Ragging is suitable for walls, furniture, or accessories. In fact, you can use this finish anywhere and in large amounts if you so choose. You will have greater success with this technique if you keep the basecoat and ragging colors close both in value (value is the lightness or darkness of a hue) and in coloration. For this demonstration, I am using mushroom semi-gloss latex paint and a water-based glaze in butter cream, but you can select any colors you like.

INSTRUCTIONS

1. Basecoat your properly prepared surface using the basecoat bristle brush and mushroom latex paint. (See photo 1.) Let this dry before continuing.
2. Pour some butter cream glaze into a paint tray. Dip a crumpled rag into the glaze, and pat off the excess glaze from the rag onto a clean, dry paint tray. (See photo 2.)
3. Begin hitting the surface with the rag in a random, overlapping manner. (See photo 3.) As you touch the surface, be sure to change the position of the rag so that you do not create the same mark repeatedly. Make sure to overlap your rag marks; if you place the marks too far apart, they will look spotty and distracting. Your goal is to achieve a soft, mottled overall pattern. Continue to hit the surface until your rag no longer makes clear marks. Reload the rag with glaze, and continue the application until the surface is covered. (See photo 4.) Be sure to blot the excess from the rag each time you pick up more glaze. If you don't do this you will get unsightly globs of glaze on the surface.

1. Apply the basecoat latex paint to the surface using the basecoat bristle brush.

2. Dip your rag into the glaze, and blot the excess off it into another paint tray.

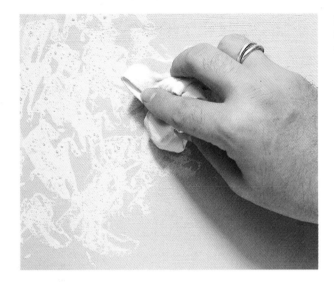

3. Begin hitting the surface with the paint-charged rag.

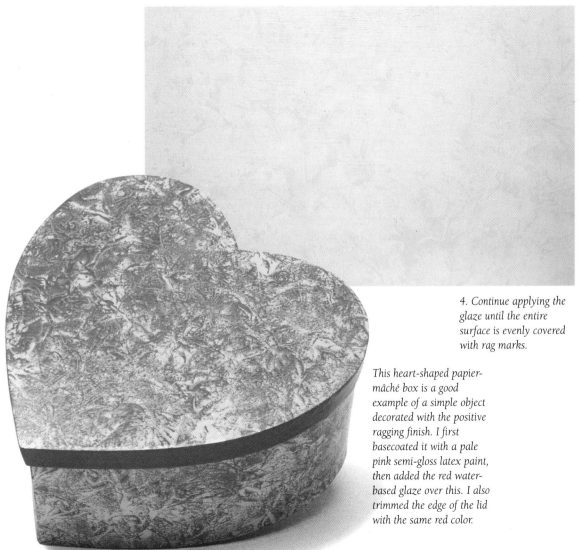

4. Continue applying the glaze until the entire surface is evenly covered with rag marks.

This heart-shaped papier-mâché box is a good example of a simple object decorated with the positive ragging finish. I first basecoated it with a pale pink semi-gloss latex paint, then added the red water-based glaze over this. I also trimmed the edge of the lid with the same red color.

Negative Ragging

MATERIALS

Paints
Light blue semi-gloss latex paint

Glazes
White water-based glaze

Brushes
Basecoat bristle brush
Glaze application brush

Miscellaneous
Paint tray
Cotton rags

Negative ragging produces one of the softest and most delicate looks of all the paint finishes. It is called negative ragging because you first apply a glaze over your entire surface, and then, using a clean, dry rag, you subtract or remove the glaze (rather than apply it as in positive ragging). You can use this finish on any interior surface, furniture, or accessory piece that you choose, and it also makes a lovely background for any decorative painted design work you may want to do. Any color can be effective, from the most subtle tone-on-tone result (either two similar colors or two values of the same color) to dramatic and bold hues. I'm using light blue and white here. As always, experimentation is your greatest learning tool when using this technique.

INSTRUCTIONS

1. Prepare the surface, and basecoat it with the light blue latex paint using the basecoat bristle brush. (See photo 1.) If necessary, allow the first coat to dry and apply a second one. You want to ensure that you have smooth, opaque paint coverage on the surface. Let the final basecoat dry before continuing.

2. Pour some white glaze into a paint tray. Using your glaze application brush, apply the glaze liberally to the surface in a random fashion, meaning in a crisscross or slip-slap manner. (See photo 2.) You do this so that you don't end up with a definite, noticeable direction to your brushstrokes. Make sure this is a *generous glaze application*. If you apply a thin layer of glaze, it will dry too rapidly; you will not be able to create the ragged finish before the glaze becomes tacky, and you will be unable to remove it and begin again. Move on to the next step before the glaze dries.

3. Crumple a rag into a soft, organic shape and begin to hit the surface to create marks. (See photo 3.) As the rag fills with color, refold it to a clean spot and continue to make marks. Be sure to change the position of the rag often. If you don't, you will repeat the same pattern on the entire surface, and your rag will fill up with glaze and not remove additional glaze effectively. Always overlap your rag marks because you want to create an overall soft, random pattern. Continue making marks in the glaze until the entire surface is ragged. (See photo 4.) On a large surface, you will need to change to a clean rag often.

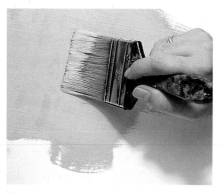

1. Basecoat the surface using the latex paint and a basecoat bristle brush.

2. Apply the glaze using the glaze application brush.

Be sure to apply the glaze generously to your surface.

If you are working on a wall, apply the glaze to a small, 2 x 3' section and rag that area before coating another section and continuing. This will allow you to keep a "wet edge" and will eliminate any distracting start and stop marks. This is because the working section is small, so the glaze won't dry by the time you move on to the next section.

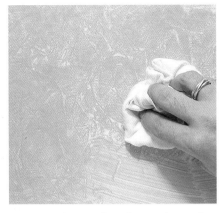

3. Begin making marks in the wet glaze with a soft cotton rag.

4. Continue making marks in the wet glaze until you cover the entire surface.

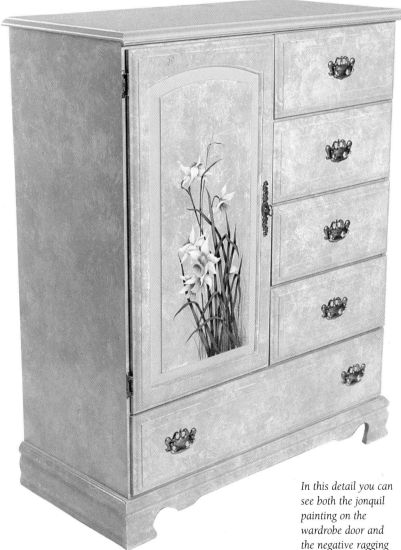

This wardrobe has a negative ragged finish in blue and white. (Here, the blue was the basecoat and the white was the overlying glaze.) The glaze tones down and softens the overall color of the basecoat.

The pink lining and trim on the drawers and top edge coordinate with the painted jonquil design. If you are incorporating a painted design into your finish, you should always try to relate the colors in the painting to the trim elements on your furniture. (See page 110 for information on decorative painting.)

In this detail you can see both the jonquil painting on the wardrobe door and the negative ragging finish behind it.

Positive Texturizing

MATERIALS

Paints
Seafoam green semi-gloss latex paint

Glazes
Forest green water-based glaze

Brushes
Basecoat bristle brush

Miscellaneous
Paint trays
Household plastic wrap

Texturizing is fascinating. When you first look at a texturized surface, you immediately think that the texture is dimensional. It is only after close inspection or on feeling the surface that you discover the dimension is only an illusion. This technique is beautiful on accessories or furniture, but don't be afraid to try it on kitchen cabinets, or walls and floors. Any surface can be enhanced with this added texture. You can use it successfully in combination with other techniques, such as marbleizing or gilding, and it also makes a beautiful background for decorative painting. In this section, I will give you instructions for three types of texturizing: positive texturizing, negative texturizing, and alligator-style texturizing. Try all three to see which one you like best.

Positive texturizing is easy and gives professional results with minimal effort. Feel free to choose different colors to achieve different effects; for example, try a dark basecoat and a light glaze for an unusual look. For this demonstration, I am using seafoam green semi-gloss latex paint with a forest green water-based glaze.

INSTRUCTIONS

1. After preparing the surface, apply the seafoam green semi-gloss latex basecoat using the basecoat bristle brush. (See photo 1.) Let this dry.
2. Pour some forest green glaze into a paint tray. Crumple a piece of plastic wrap into a loose ball, and dip it into the glaze. Blot off the excess glaze by dabbing the wrap on a clean, dry tray. (See photo 2.) This will allow you to check how much glaze is on the plastic and to see what kind of marks the wrap will make.
3. Begin dabbing the surface with the loose ball of plastic wrap, making sure to change the position of the plastic wrap as you move across the surface. (See photo 3.) Be sure to overlap the marks; this will make the overall pattern more consistent. As the plastic wrap becomes dry, pick up more glaze, being sure to remove the excess on a paint tray before applying it to the surface. Change the plastic wrap when it becomes too compact and no longer leaves a nice imprint in the glaze. Continue to dab and make marks. (See photo 4.) After you complete the surface, look carefully at the overall effect. If necessary, go back and add some more texture to any areas that seem too light or too sparse in pattern.

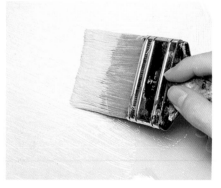

1. Basecoat the surface with the semi-gloss latex paint using your basecoat bristle brush.

2. Place some glaze in a clean paint tray, and then pick a bit up on a loosely crumpled ball of plastic wrap. Blot the excess glaze from the plastic by dabbing it in a clean tray.

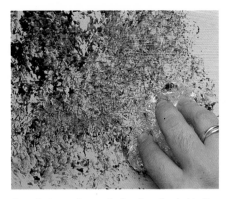

3. Dab the surface with the glaze-loaded ball of plastic wrap.

4. Continue to hit the surface with the plastic wrap until it is completely covered with texture.

This simple lamp and shade have been elevated to the level of art by the application of a positive texturizing finish.

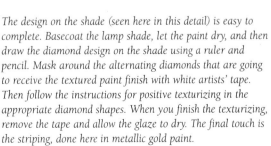

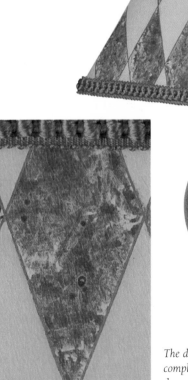

The design on the shade (seen here in this detail) is easy to complete. Basecoat the lamp shade, let the paint dry, and then draw the diamond design on the shade using a ruler and pencil. Mask around the alternating diamonds that are going to receive the textured paint finish with white artists' tape. Then follow the instructions for positive texturizing in the appropriate diamond shapes. When you finish the texturizing, remove the tape and allow the glaze to dry. The final touch is the striping, done here in metallic gold paint.

Negative Texturizing

MATERIALS

Paints
Light pink semi-gloss latex paint

Glazes
Burgundy water-based glaze

Brushes
Basecoat bristle brush
Glaze application brush

Miscellaneous
Paint trays
Household plastic wrap

Negative texturizing gives a softer look than the positive technique. The reason for this is that by layering a glaze over your entire surface, rather than just dabbing it onto the ground, you tint the entire background, completely altering its color. For a very sophisticated, tone-on-tone effect, try using this technique with base and glaze colors that are very close in hue and value. This is especially lovely when you choose beige and cream tones. I use light pink and burgundy here.

INSTRUCTIONS

1. Prepare the surface, and then apply two coats of the light pink semi-gloss latex paint using your basecoat bristle brush. (See photo 1.) Let this dry before proceeding to the next step.
2. Pour some burgundy glaze into a paint tray. Apply it to the surface using your glaze application brush. (See photo 2.) Be sure to apply a generous coat of glaze. If it is too thin, it will begin to set up (become unworkable as it dries) and become tacky before you can make your marks in it. Move on to the next step before the glaze dries.
3. Using a piece of household plastic wrap that you have formed into a loose ball, begin to dab the surface to make the texture in the glaze. (See photo 3.) As you do this, change the piece of plastic wrap as often as it becomes clogged with glaze. If you continue to use the same piece of plastic wrap, you will not remove any glaze, and the surface will show a value change from light (where you start) to dark (where you finish). You want an even, overall mottled look. Continue dabbing until the surface until it is completely texturized. (See photo 4.)

1. Apply the basecoat color using the basecoat bristle brush.

2. Apply a liberal coat of glaze to the surface using the glaze application brush.

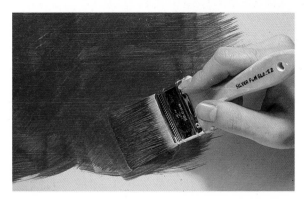

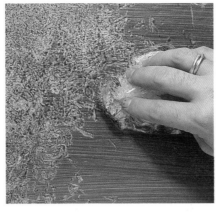

3. Using a ball of plastic wrap, begin making marks in the wet glaze.

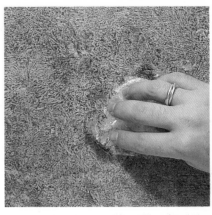

4. Continue making marks in the wet glaze until the you cover the entire surface.

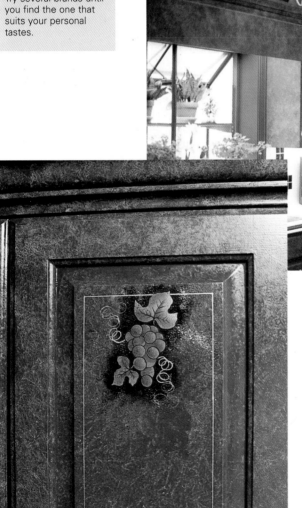

The cabinets in this kitchen were painted using the negative texturizing technique. You can use this simple paint finish to give cabinets a face-lift, and by changing the look of your cabinets, you can transform your entire kitchen.

The grape motif on the cabinet doors was completed with imitation gold leaf, although you could also use gold foil. Notice the gold lining, too.

Alligator-Style Texturizing

MATERIALS

Paints
Midnight blue semi-gloss latex paint

Glazes
Washed-denim water-based glaze

Brushes
Basecoat bristle brush
Glaze application brush

Miscellaneous
Household plastic wrap

This is my favorite type of texturizing. The look reminds me of alligator or some other exotic animal skin. You can apply this finish to furniture, accessories, or walls; no matter where you use it, you will make an impact. I am using a midnight blue latex paint and a washed-denim glaze, but you can select any colors you want. Try using a different combination of basecoat and glaze; the look of a dark glaze over a light basecoat is totally distinct from that of a light glaze over a dark basecoat.

INSTRUCTIONS

1. Prepare the surface properly, and apply the midnight blue semi-gloss latex paint using the basecoat bristle brush. (See photo 1.) If necessary, let this first coat dry and apply a second layer. You want a smooth, opaque covering of basecoat paint on the surface. Let this dry before moving on to the next step.
2. Using the glaze application brush, apply a liberal coat of washed-denim glaze to the surface. (See photo 2.) If the layer is too thin, the glaze will become tacky before you have a chance to manipulate it.
3. While the glaze is still wet, lay a loosely wrinkled piece of plastic wrap over it. Pat the plastic wrap with your hands to make sure that it is in contact with the glaze. (See photo 3.) Let it rest on the surface for a minute or two.
4. Gently pull the plastic wrap off the surface to reveal the pattern. (See photo 4.) If your marks disappear, you may have put too much glaze on the surface. Simply reapply the plastic wrap, and you should get a better pattern.

1. Apply the latex basecoat with your basecoat bristle brush.

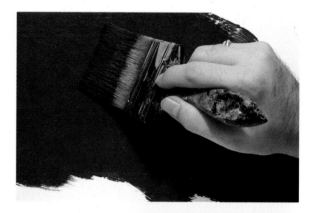

2. Apply an ample coat of glaze with the glaze application brush.

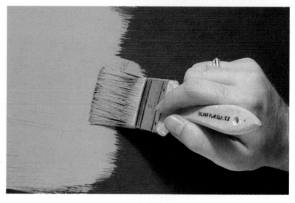

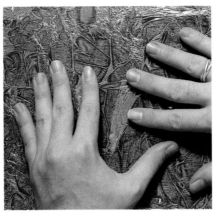

3. Lay a slightly wrinkled piece of plastic wrap over the wet glaze, and pat it with your hands to make sure it is in contact with the glaze.

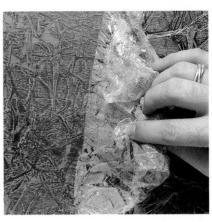

4. Pull the plastic wrap off the surface to reveal your texturized pattern.

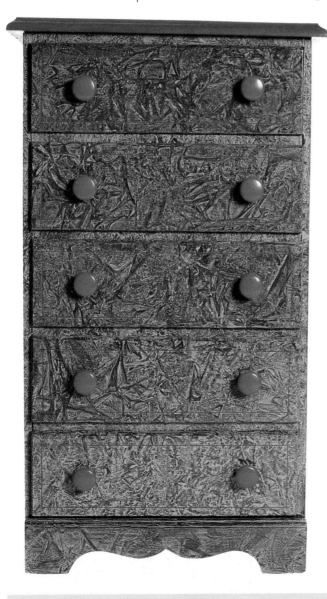

I gave this antique chest new life with alligator-style texturizing, done here in two shades of blue. New red hardware adds a playful touch. By trimming the drawers and edges of the chest with red, I was able to tie in the red handles to the finished design.

Lining, as seen here in this detail of the chest drawers, can add a design element to almost any surface. (See page 104 for lining instructions.)

DISTRESSED FINISHES

Distressed finishes impart a warm feeling to furniture and interior spaces. A mellow charm overtakes any piece that is lovingly distressed. You simply can't make a mistake with any of these finishes, and the variety is endless. For example, color choices allow for the use of these finishes in many different decorating schemes, from very sophisticated to country casual. You can also choose how lightly or heavily you distress an item. A little distressing can show light wear, while heavy distressing can impart the look of a well-worn "antique." Open your mind to the variations you can create by just changing colors or by combining several of these techniques.

Distressing

MATERIALS

Glazes and Glazing Mediums
Dark brown water-based glaze
Clear, oil-based glazing medium

Paints
Cream flat latex paint
Burnt umber artists' tube oil color

Brushes
Glaze application brush
Basecoat bristle brush

Miscellaneous
Cotton rags
#220 grit sandpaper
#400 grit sandpaper
Sanding block
Hammer
Nails
Awl
Paint tray
Palette knife

Scratched, beaten, and banged up. These words describe the distressed finish, one of the most therapeutic and stress-relieving painted finishes that you can execute. Distressing is perfect for any surface that is already a bit shopworn—primarily old, wooden furniture. By using it, you can give any piece (new or old) the look of an antique. The charm of this technique is timeless. If you are working on a surface that is already stained or finished, you can proceed directly to step 3 of the instructions, as long as you sand the surface lightly first to give it tooth. (This rough texture will allow for better paint adhesion.) Be aware that this finish will require two days to complete, as you will see below, so you should make sure you plan your time accordingly. Also keep in mind that you don't have to use the same colors that I do here; you can choose any hues you like.

INSTRUCTIONS

1. Stain the surface using dark brown water-based glaze, using the glaze application brush.
2. Before it dries, wipe the excess glaze from the surface with a soft cotton rag, and allow the stain to dry overnight. (See photo 1.)
3. Using the basecoat bristle brush, apply the top color of flat latex paint. (See photo 2.) I'm using a cream-colored paint here. Try to achieve smooth, even paint coverage. If you need to apply a second coat, allow the first to dry completely before applying the second. Let this top color dry before proceeding.
4. Sand areas of the topcoat away using the #220 grit sandpaper. (See photo 3.) Continue sanding areas with #400 grit sandpaper. (The sanding block is helpful for this.) You should sand until you see the underlying stain. Emphasize the sanding on edges, corners, or any spot that would normally receive heavy usage and wear.
5. Now you are ready for the fun part—the distressing. Using the claw end of the hammer, create some gouges in the surface. Then hit the surface with the face (the flat end) of the hammer to add a few dents. You may also want to scratch the surface with a nail or the side of a screw. (See photo 4.) Add a few "worm holes" with the awl. When using the hammer and nails, be careful not to overdo it—there is a fine line between distressed and destroyed.
6. Lightly sand the distressing. Use #400 sandpaper for this, and gently sand the entire surface. This will eliminate any burrs that may have been raised in the previous step. This is very important; you must remove these splinters at this stage in order to have a nicely finished piece.
7. In a paint tray, mix some burnt umber oil paint into some of the clear, oil-based glazing medium to create a transparent earth-tone glaze. Blend the paint and glazing medium together well with the palette knife. Apply this glaze to the surface with the glaze application brush. (See photo 5.) Note that you can choose another color for this glaze, but this earth tone is the best for an authentic-looking distressed or old appearance.
8. Before it dries, wipe the excess glaze from the surface with a clean, soft cotton rag. (See photo 6.) You might need to rub vigorously to do this because the glaze will seep into the flat latex paint. If the glaze does not wipe off the paint, moisten your rag with some mineral spirits and try again. You might have to repeat this step several times to get the desired look, which is a toned-down one—an overall antiqued and mellowed feel.

1. Stain the surface with your water-based glaze, wipe off the extra with a clean, soft rag, and let it dry overnight.

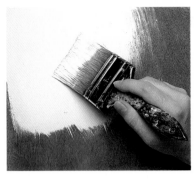

2. Apply a topcoat of flat latex paint with the basecoat bristle brush. Let dry.

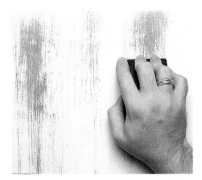

3. Sand away areas of the topcoat using #220 grit sandpaper. Then switch to the #400 grit and continue sanding.

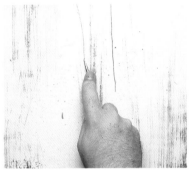

4. Distress the surface using a hammer, nails, and an awl.

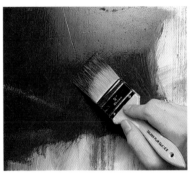

5. Apply the earth-tone oil-based glaze with the glaze application brush.

6. Remove excess glaze with a clean, soft cotton rag.

I completed the background of this little tavern sign using the distressing technique. I painted the black-eyed Susans on top of the finish.

TIPS
To create added interest, have contrast between your underlying stain color and your top color.

A satin-finish varnish is the most appropriate type to use with this technique. (See page 124 for varnishing guidelines.)

I achieved the variety of marks that you see in this close-up detail with a few different tools: a hammer, screwdriver, and awl.

Rubbed Finish

MATERIALS

Paints
Dark blue flat latex paint
Beige semi-gloss latex paint
Burnt umber artists' tube oil color

Glazing Mediums
Clear, oil-based glazing medium

Brushes
Basecoat bristle brush
Glaze application brush

Miscellaneous
#220 grit sandpaper
#400 grit sandpaper
Sanding block
Paint trays
Palette knife
Cotton rags

The rubbed finish, with its rich coloration, is one of the loveliest distressed finishes that you can create. It has the appearance of paint that's been worn off with use and age. Try a variation using a light base color and a dark top hue, which will give an unusual and interesting look. The glazing step is optional, but a glaze imparts a warmth to the finished piece and produces a more unified look than would be achieved without it. You can opt for a more colorful glaze than an earth tone if you so desire. This technique is commonly used on wooden furniture.

INSTRUCTIONS

1. Begin by basecoating the prepared surface using the basecoat bristle brush and the flat latex paint. (See photo 1.) You should have nice, even paint coverage. If necessary, let the first coat dry and apply a second one. Be sure to allow this basecoat to dry completely before proceeding.

2. Apply your topcoat of semi-gloss latex paint with a clean basecoat bristle brush. (See photo 2.) You may have to apply two coats to completely cover your first color. Allow this topcoat to *cure* before you begin distressing the surface. This means to let the paint dry *completely*—more than just dry to the touch.

3. Using the #220 grit sandpaper and sanding block, begin to sand away some of the topcoat. Try to sand in places that would normally receive wear and tear, such as edges and corners. Once you remove some of the top color, begin to "artfully" sand away other areas. (See photo 3.) You want to achieve a nicely worn pattern on the surface. With the #400 grit sandpaper, begin to smooth out the areas that you previously sanded. This will help gradually feather out the sanding marks and will give a smoother overall finish to the sanding. It will also even out any gouges that the coarser sandpaper may have left in the surface.

4. Prepare a glaze by adding some of your oil color (here, burnt umber) to a tray of clear, oil-based glazing medium. Mix the paint and glazing medium together well with the palette knife. This color should be transparent. Using the glaze application brush, apply the glaze to the piece. (See photo 4.) It will grab in (soak into) the sanded areas. Don't worry that they are darker at this point. Move on to the next step before this dries.

5. Wipe the glaze off with a soft cotton rag. (See photo 5.) You can remove as much of it as you wish. If the glaze remains stubborn in any areas, moisten your rag with some mineral spirits, and wipe the surface again. Try to smooth the glaze as much as possible with your rag.

1. Apply your basecoat color using the basecoat bristle brush and allow to dry.

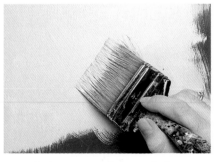

2. Apply the top-coat color using the basecoat bristle brush. Let this dry completely.

TIPS

A sanding block can help you manipulate the sandpaper and make sanding the piece much easier.

Satin varnish will add a mellow look to the completed piece. (See page 124 for complete varnishing guidelines.)

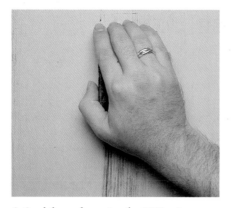

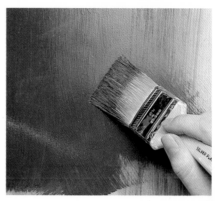

3. Sand the surface using the #220 grit sandpaper.

4. Apply the glaze with the glaze application brush.

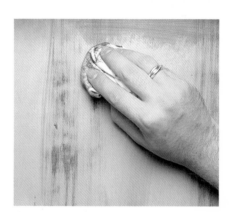

5. Wipe the glaze off using a soft cotton rag.

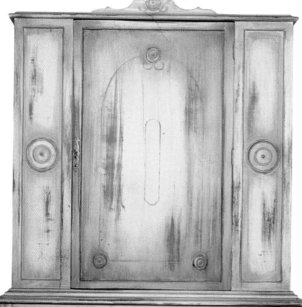

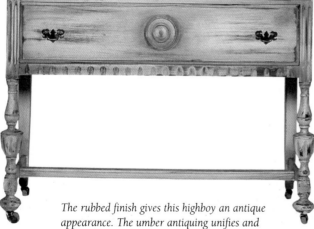

The rubbed finish gives this highboy an antique appearance. The umber antiquing unifies and mellows the surface. For a more subtle look, choose paint colors that are more closely related than the blue and cream tones on this piece.

In this detail of the highboy you can clearly see the rubbed-finish effect.

Flaking Paint

MATERIALS

Paints
Beige flat latex paint
Off-white semi-gloss latex paint
White artists' tube oil color

Glazing Mediums
Clear, oil-based glazing medium

Brushes
Basecoat bristle brush
Glaze application brush

Miscellaneous
Cotton rags
Petroleum jelly
Paint trays
Palette knife

Heat, humidity, and time cause paint to crack and peel. Most often, flaking paint is undesirable. However, antiques often gain significantly in charm and appeal due to their coats of flaking paint. In fact, furniture that has an interesting coat of flaking paint can often fetch more in a retail store than a piece which has been stripped or refinished. This finish is best suited to wooden furniture but can also be used on terra-cotta and metalware accessory pieces as well. Feel free to experiment with different colors, too.

Creating the look of flaking paint is an intriguing process. It requires some patience, as paint must dry overnight. But if you can wait a day, you can create a look that often takes nature years to produce.

INSTRUCTIONS

1. Basecoat the properly prepared surface with a beige or sand-colored flat latex paint using the basecoat bristle brush. (See photo 1.) If necessary, let the first coat dry and apply a second. You want a smooth, opaque application of paint on the surface. Allow the basecoat to dry thoroughly.

2. Using a rag, apply a thin coating of petroleum jelly to the areas where you eventually want the paint to flake off the surface. (See photo 2.) Do not apply too much petroleum jelly to the surface; a thin coating is best. Globs of it will cause problems later on. You should also keep some areas free of petroleum jelly.

3. Apply a coat of a cream-colored or off-white semi-gloss latex paint over the entire surface using a clean basecoat bristle brush. (See photo 3.) The paint might ciss, or bead up, and not want to stick, but don't be concerned about this. Allow this coat of paint to dry overnight.

4. Using a cotton rag, begin to wipe or rub the surface where you applied the petroleum jelly. (Sometimes these areas will ciss and, therefore, be apparent; otherwise, you will need to remember where you applied the jelly.) The paint will pull apart and rub off in those places. (See photo 4.) When rubbing, apply quite a bit of pressure; you want to remove any paint that will come off the surface. Try to wipe all traces of petroleum jelly from the surface, as well, so that you avoid problems with the paint flaking off where it shouldn't later.

5. Prepare a white, oil-based glaze by mixing the white oil paint into a tray of clear, oil-based glazing medium. Blend the paint and glazing medium with the palette knife. Apply this to the surface using the glaze application brush. (See photo 5.) When you make the glaze, be sure it is not too transparent. If it does appear too translucent, add some more oil paint to the mixture and then reapply. Move on to the next step before the glaze dries.

6. Wipe the excess glaze from the surface using a soft cotton rag, but don't wipe off too much. (See photo 6.) If you remove too much, you will defeat the purpose of the glaze, which is to unify the overall appearance of the piece.

7. When the glaze is dry, apply a satin-finish varnish to help seal the surface and add a mellow sheen. (See page 124 for these instructions.)

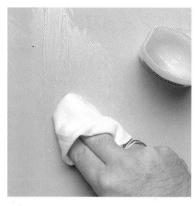

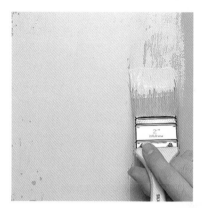

1. Apply the basecoat color using the basecoat bristle brush, and let it dry thoroughly.

2. Using a rag, apply thin splotches of petroleum jelly.

3. Cover the entire surface with a coat of semi-gloss latex paint using the basecoat bristle brush. Let this dry overnight.

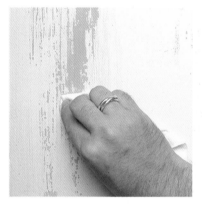

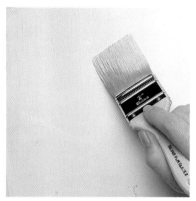

4. Rub the areas that have petroleum jelly underneath them with a rag.

5. Apply a coat of oil-based glaze with the glaze application brush.

6. Wipe the excess glaze from the surface with a soft cotton rag.

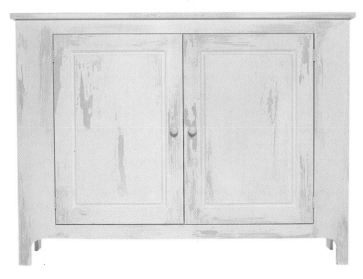

The flaking paint finish belies the fact that this sideboard is new. I chose light, neutral colors for this piece, but you could also use two contrasting colors for a different look.

By using petroleum jelly, you can easily create the effect of flaking or peeling paint seen in this close-up.

Chinese Linen

MATERIALS

Paints
Black satin latex paint
Red gloss latex paint

Varnishes
Gloss varnish

Brushes
Basecoat bristle brush
Varnish application brush

Miscellaneous
Liquid hide glue
Burlap fabric
Rubber brayer or rolling pin
X-Acto knife
#150 grit sandpaper
#220 grit sandpaper
#400 grit sandpaper
Sanding block

This finish is a modern adaptation of an Oriental lacquer technique. Traditional Oriental lacquer originated in the 15th century. Originally, lacquer was made from the resin of an Asian sumac, *Rhus verniciflua,* and lacquering a piece was a very time-consuming and laborious task. As many as 30 coats of lacquer were applied to a surface with polishing in between each application.

To achieve this variation of lacquered linen we'll use modern acrylic paints and burlap. This distressed linen finish is well suited to boxes or small tables; however, it can also be very exciting and dynamic if used on walls or doors. And, it works well on any surface material. For use on interior surfaces, you could eliminate some of the varnishing and allow the texture to remain apparent. For this demonstration, I am using traditional Oriental colors of red and black, but feel free to change the coloration to suit your own personal taste and decor. Just make sure that you use the same paint finishes, for example satin finish for the basecoat and gloss for the topcoat. As with the flaking paint technique, the Chinese-linen finish requires a bit of patience because some materials must dry overnight, but the results are well worth the wait.

INSTRUCTIONS

1. Apply a liberal coat of liquid hide glue to the surface using a brush. This glue, made from animal hides, is available at woodworking shops and some hardware stores. Make sure you use a *prepared* liquid hide glue. Do not use a granular hide glue that you prepare yourself. It is preferable that the surface be raw wood (so you don't have to finish it). If the surface is not raw wood, be sure to sand it thoroughly to give it some tooth (or texture). This will help the glue adhere the fabric properly.

2. While the glue is wet, place the burlap fabric on the surface. Press it into place with your fingers, and then roll over it with the rubber brayer or rolling pin to remove any air pockets and ensure that the burlap is in complete contact with the surface. (See photo 1.) As you use the brayer, roll from the center of the piece toward the edges. Allow the glue to dry for 24 hours.

3. Trim off any excess fabric with an X-Acto knife. The fabric will be stiff and easy to cut at this point.

4. Using the basecoat bristle brush, apply a coat of black satin latex paint to the surface. (See photo 2.) This will take a little effort as the burlap will soak up the paint. When this coat is dry, apply a second and third one as needed. You must be sure to completely fill the weave of the burlap with paint. At this point, the fabric texture will still be very evident. Let this paint dry before continuing.

5. Apply two coats of red gloss latex paint using a basecoat bristle brush. (See photo 3.) Be certain to fill in the weave of the burlap. You should have an even covering of red on the surface with no black visible. Try to apply only two coats of red; layering on more coats will only cause you more work when you sand them away in the next step. Allow this paint to dry overnight.

6. Begin sanding with the #150 grit sandpaper. A sanding block is very helpful for this. At this point, you will begin to reveal the black paint and the weave of the fabric. (See photo 4.) As this happens, change to #220 grit paper and feather out the sanded areas. Finally, change to #400 grit paper and smooth the surface. Pay attention as you sand. Be careful not to sand through the black basecoat. As soon as you see that you are removing the red color, move to

TIP
To help scrub the black paint into the fabric, stand the brush on its end and tap the bristles into the fabric to force the paint into the crevices of the weave.

another area or change to a finer grit sandpaper. You should also keep some areas entirely red. As the sandpaper becomes clogged, change it. You will see better results with less work if you keep your sandpaper fresh.

7. Varnish the surface. Use a clear, high-gloss varnish, and apply it with a varnish application brush. You will need to put on many, many coats of varnish. The goal is to have a smooth surface and to completely conceal or seal the burlap texture. This could take as many as 15 coats of varnish. As you varnish, be sure to allow adequate drying time between coats. (See page 124 for varnishing information.)

1. Glue the burlap to the surface. Smooth any air pockets with a rubber brayer, and let the glue dry for 24 hours.

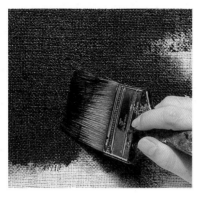
2. Apply the black satin latex paint with a basecoat bristle brush, making sure to fill the weave of the fabric with the paint.

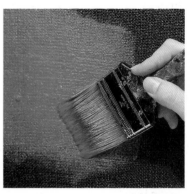
3. Using the basecoat bristle brush, cover the surface with the red gloss latex paint. Again, be sure to fill the weave of the fabric.

4. After letting the red paint dry overnight, sand the surface to reveal the weave of the fabric in black.

The modern version of this ancient technique is well suited to the clean, contemporary lines of this console table. The linen finish works best on simple, uncluttered furniture pieces. Try it in different colors to suit your decor.

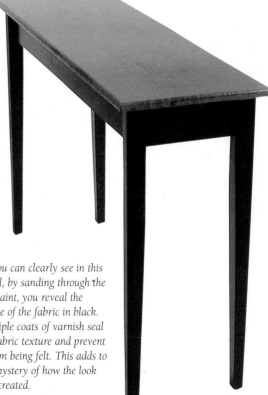

As you can clearly see in this detail, by sanding through the red paint, you reveal the weave of the fabric in black. Multiple coats of varnish seal the fabric texture and prevent it from being felt. This adds to the mystery of how the look was created.

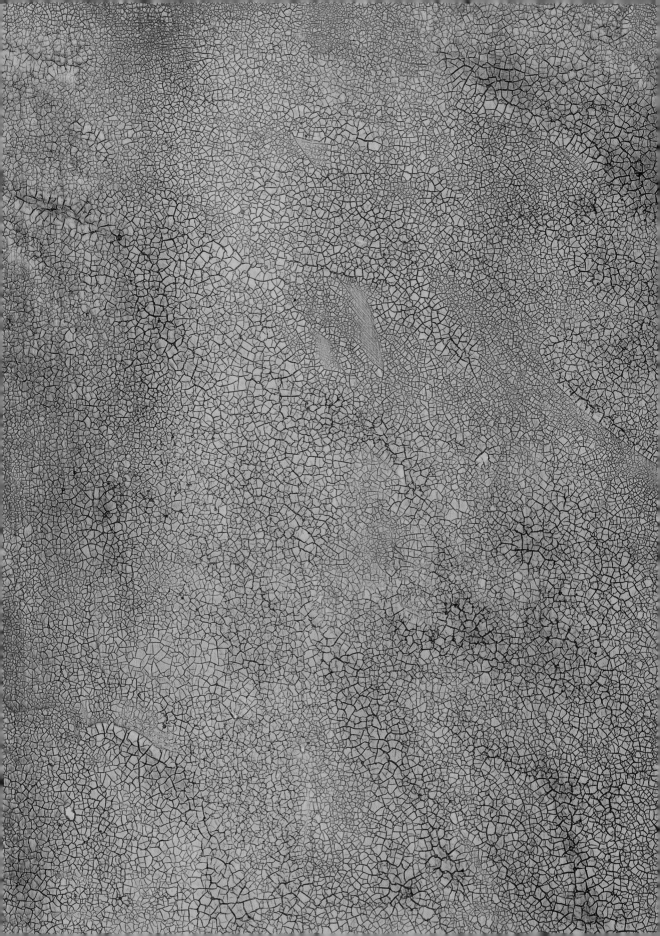

CRACKLE FINISHES

Age isn't often kind to furniture or paint. One thing that time does is cause a surface or varnish to crack. Many times, however, these cracks add a certain charm or a quality of patina to a piece, making it much more visually interesting than it was before the effects of time. Fortunately, we no longer have to wait for time to produce crackle finishes; we can create an aged appearance almost instantly.

The techniques in this chapter offer a variety of looks. Some crackle finishes work only as backgrounds or finished effects unto themselves, as with the weathered paint method, while others, such as chemical crackling and crackle varnish (also called cracklure) can be used either as painted finishes alone or over decorative treatments such as painted designs or decoupage, which are covered later on in this book. All of the crackle finishes are somewhat hit or miss. They are also very sensitive to temperature and humidity. Always approach them with a sense of adventure and risk. Chances are you'll be pleased with your efforts.

Chemical Crackling

MATERIALS

Paints
Yellow flat latex paint

Mediums
Crackle medium

Glazes
Dark brown water-based glaze

Brushes
Basecoat bristle brush
1" square wash brush
Glaze application brush

Miscellaneous
Paint tray
Water
Palette knife
#400 grit sandpaper
Paper towels
Cotton rags

Chemical crackling involves the use of a special crackling agent. This crackling technique produces a finish similar to the cracks that develop on china- or dinnerware. You can use it alone as a decorative element or can combine it easily with other techniques to produce a piece that looks very old. Note that the crackle medium will need to dry overnight, so you will need a bit of time for this process. Practice on a scrap surface first to acquaint yourself with the working properties of the crackle medium before attempting to work on your finished surface. This technique will work on any painted surface, and you can use any colors.

INSTRUCTIONS

1. Prepare the surface, and apply the flat yellow latex paint as a basecoat color using the basecoat bristle brush. (See photo 1.) Let this coat dry, and quickly apply another. Allow only enough time for the first coat to become dry to the touch before applying the next one. Apply four coats of paint in this manner, and let the final coat dry to the touch, as well. Note that you must apply the basecoats in quick succession or the crackle medium will not work well. If you are executing this over a previously decorated surface, apply several coats of a water-based polyurethane varnish in rapid succession over the design, then apply the crackle medium as per the next step.

2. Put some crackle medium in a paint tray, and thin it with just a bit of water. Crackle medium is very thick straight from the jar, and thinning it just slightly will help you brush it out. Use the palette knife to blend the medium and water together. Apply the thinned mixture to the whole surface (or wherever you want the cracks to be) with the 1" square wash brush. (See photo 2.) Use a slip-slap or crisscross motion to apply the medium. Note that a thick layer will result in a large overall crack pattern, while a thinner application will create a smaller, delicate crack pattern. Let this dry overnight. You should put down only one layer of crackle medium. Applying a second coat will not help the results—it will only create a layer of fine fractures over the already existing crackle pattern.

3. After the crackle medium is dry, lightly sand the surface, if necessary, to minimize any offensive ridges. You should use #400 grit sandpaper for this.

4. Using a glaze application brush or a clean rag, apply a moderate coating of the dark brown water-based glaze to the surface. (See photo 3.) This will fill in the cracks, making the crackle pattern visible. Move right on to the next step without letting this dry.

5. With a paper towel, begin to remove the excess glaze from the surface. (See photo 4.) If you want a more antiqued surface color, leave some glaze on the surface; if not, wipe away as much as possible. Switch to a soft cotton rag to continue this removal process and to soften the overall look of the antiquing. If the glaze is stubborn and will not rub off easily, moisten the rag with a small amount of water and try rubbing the surface again. Finish buffing with a dry cloth.

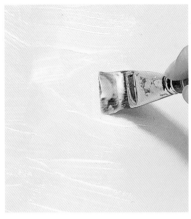

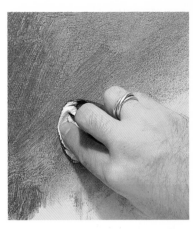

1. Apply the flat latex basecoat with a basecoat bristle brush.

2. Apply the crackle medium with a 1" square wash brush and let dry overnight.

3. Using a clean cotton rag, apply some water-based glaze to the surface. You can also use a glaze application brush.

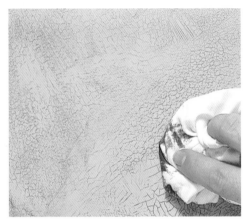

4. Wipe the excess glaze from the surface first with a paper towel and then with a soft cotton rag.

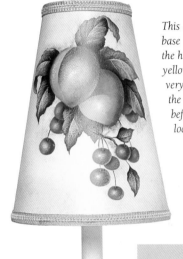

This crackle finish candlestick lamp base is the perfect complement to the handpainted lamp shade. The yellow tones coordinate to give a very customized look. I purchased the base, which was plain white before its transformation, at a local department store.

On this sample board, I applied the crackle medium to a light blue basecoat and then antiqued it with black glaze. The differences in the size of the cracks resulted from differences in the thickness of the crackle medium applications.

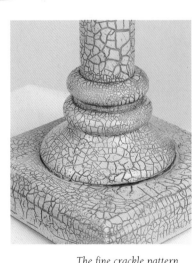

The fine crackle pattern, produced by the crackle medium, is emphasized by brown antiquing.

Crackle Varnish

MATERIALS

Paints
Violet flat latex paint
Titanium white artists' oil
color

Varnishes
Aging varnish (part one of
the two-part crackle
system)

Crackle varnish (part two
of the two-part crackle
system)

Glazing Mediums
Clear, oil-based glazing
medium

Brushes
Basecoat bristle brush
1" square wash brush
Glaze application brush

Miscellaneous
Paint tray
Palette knife
Cotton rags

Cracked varnish adds an air of mystery and age to a painted surface. This two-part technique produces a natural cracked-varnish pattern. You can apply this crackle finish over decorative design work for an antique appearance, or you can use it as an overall finish on its own. And, you can use it on any painted surface. I do recommend, however, that you try it on a scrap surface before applying it to one that you have worked on for a long time. This technique is the most sensitive of all the crackle processes to heat and humidity, making it a risky but beautiful finish. You can experiment with different colors for both the background and the glaze, or for a more traditional crackle antiquing color, use a mixture of burnt umber and black oil paints to make your glaze. For this demonstration, I'm using a violet background color and a white glaze.

INSTRUCTIONS

1. Basecoat the surface with the violet flat latex paint using the basecoat bristle brush. (See photo 1.) If necessary, let the first coat dry and apply a second one. Allow this basecoat to dry completely before proceeding.

2. With the 1" square wash brush, apply a thin coat of the aging varnish. (See photo 2.) This will make the surface very glossy and slightly yellow.

3. When the aging varnish is sticky (after approximately one hour, depending on room temperature and humidity), apply a coat of crackle varnish. (See photo 3.) Use a clean 1" square wash brush for this, as well. (You can clean aging and crackle varnishes from your brushes using mineral spirits.) Make sure you apply the crackle varnish while the aging varnish is still tacky—if you wait until the aging varnish is dry, no cracking will occur. Once you apply it, allow the crackle varnish to dry completely.

4. On a paint tray, mix some white oil color into some clear, oil-based glazing medium. Mix these well with the palette knife. With a glaze application brush, apply this white glaze to the surface. (See photo 4.) Do not apply any water-based glazes to the surface; they will gum up and ruin your finish.

5. Before it dries, wipe the excess glaze from the surface with a soft cotton rag. (See photo 5.) The white will remain in the cracks, making them more visible.

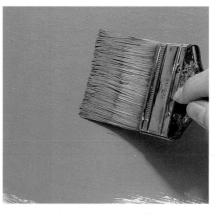

1. Basecoat the surface with the flat latex paint and a basecoat bristle brush.

2. With a 1" square wash brush, apply a thin coat of aging varnish.

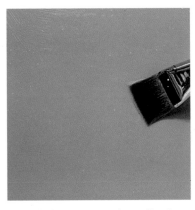

3. While the aging varnish is still tacky, apply a coat of crackle varnish.

4. Apply the oil-based glaze with the glaze application brush.

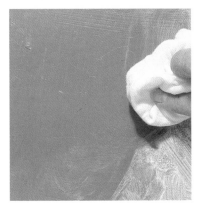

5. With a soft cotton rag, remove the excess glaze.

TIP
If after one hour you do not see any signs of cracking, apply a little heat with a blow drier. Stop as soon as you see any evidence of cracking.

The antique pansy prints, which I applied to this frame using the decoupage technique, seemed to call for a crackle varnish.

This is a detail of the frame in the above picture. The white glaze provides a different twist, helping to lighten the look of the frame. Using a light basecoat and a dark glaze would result in a more traditional look.

Weathered Paint

MATERIALS

Paints
Black semi-gloss latex paint
Turquoise artists' tube acrylic

Brushes
Basecoat bristle brush
Glaze application brush
1" square wash brush

Miscellaneous
Liquid hide glue
Paint tray
Water
Palette knife
Clear acrylic spray

The effect of weather on paint is absolutely fantastic. Wood that has been painted continues to expand and contract with changes in temperature and humidity, but the paint film on the wood doesn't and is, therefore, subject to cracking and tearing. With a little practice, you can create the look of weathered paint. Try different combinations of base colors (the hues that will show through the cracks) and top colors. This technique is a little challenging, so I would recommend that you practice on a scrap surface before beginning your project. It also requires some patience because the hide glue that you use needs to dry overnight.

INSTRUCTIONS

1. Prepare the surface, and apply a coat of semi-gloss latex paint using the basecoat bristle brush. (See photo 1.) If necessary, allow the first coat to dry and apply a second one. Let this dry before continuing.
2. With a glaze application brush, apply a coat of hide glue to the surface, and allow it to dry overnight. (See photo 2.)
3. In a paint tray, dilute the acrylic paint with water until it is a nice, flowing consistency. The viscosity should be like that of a heavy cream soup so that the application is smooth and uniform. Use the palette knife to mix this well.
4. Load the 1" square wash brush with this thinned paint mixture (the brush should be fully loaded with paint), and with quick and deliberate crisscross strokes, apply the color to the surface. Apply the paint rapidly, reloading the brush as necessary. The cracking and tearing reaction will take place immediately as you are working. (See photo 3.) *Do not* brush back over an area. The paint is literally floating on the dried glue, and any attempt to go back over an area will result in a smearing of the crackle pattern. If you must retouch an area, allow the paint to dry thoroughly, and then carefully brush more color over any spots that you missed. Take great care not to disturb the paint that is already on the surface. Let this paint application dry completely. Note that if you are not satisfied with your effort, you can wash the crackle pattern away with water, let the surface dry, reapply your glue, and proceed from there.
5. At this point the painted surface is very fragile. Any moisture could loosen or move the paint on the surface. To prevent any damage, spray the surface with a clear acrylic spray. This will seal and protect the surface, and prepare it for antiquing or varnishing. (See photo 4 for the completed finish.)

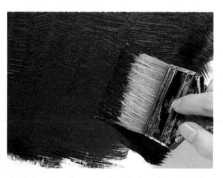

1. Using your basecoat bristle brush, apply the semi-gloss latex basecoat.

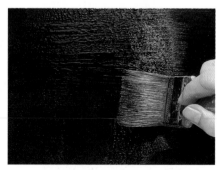

2. Put down a coat of liquid hide glue with the glaze application brush and let dry overnight.

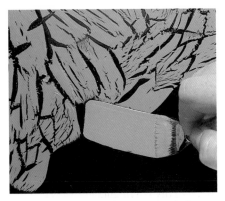

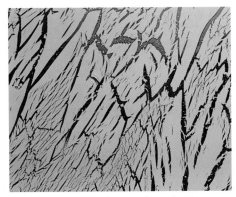

TIPS
You can achieve a dramatic look by using metallic gold as a basecoat and black as a topcoat. The application of antiquing can also add another dimension to this finish; before applying any antiquing be sure to spray your surface with a clear acrylic spray. (See page 116 for antiquing instructions.)

3. Apply the thinned acrylic paint with the 1" square wash brush in a slip-slap manner. Do not brush back into an area once you paint it.

4. The finished effect.

In this weathered paint example, I used a dark teal basecoat with a medium-value green topcoat. For a subtler effect, choose base- and topcoat colors that are closer in value.

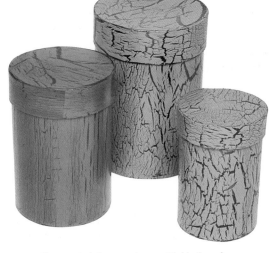

Heavy antiquing over a weathered paint finish of burnt umber and asphaltum paint colors gives the effect of wood grain.

I basecoated these canisters with black and achieved the random peeling paint effect with artists' tube acrylic colors. The turquoise and sienna hues are indicative of the Southwest.

Light antiquing, using asphaltum and burnt umber oil paint colors, is here enhanced with flyspecking. (See page 96 for flyspecking instructions.) I executed the antiquing and flyspecking over a weathered paint finish that I created from a black basecoat and a mushroom topcoat.

This example clearly shows how antiquing can add to the weathered paint technique. I used a dark brown basecoat with a taupe topcoat and antiqued the right half of the panel with raw umber. (See page 116 for antiquing instructions.)

MARBLEIZING

Of all the faux finishes, marbleizing ranks at the top of the list in both popularity and mystery. The painted illusions that you can produce are spectacular. You can create depth and dimension that will fool any viewer and possibly even amaze yourself. None of the marbleizing techniques are too difficult to master if you concentrate on completing each step before moving on to the next. And, don't be afraid to experiment with different color combinations; the colors presented here are only suggestions. Let your imagination be your guide.

White Carrara Marble

MATERIALS

Paints
Black semi-gloss latex paint
White semi-gloss latex paint

Glazes
Black water-based glaze
White water-based glaze

Brushes
Basecoat bristle brush
Glaze application brush

Miscellaneous
Paint trays
Palette knife
Household plastic wrap
Toothbrush
Odorless turpentine or mineral spirits
Feather

This subtle marble finish lends itself well to a variety of surfaces. It is appropriate for tabletops and accessory pieces but is also attractive on interior moldings and trim. Carrara marble is also suitable for floors and sections of walls, such as the area below a chair rail. This finish is primarily executed in white, but the technique could be used to render another marble color, like blue or purple.

The use of plastic wrap makes it easy to master this finish and to achieve a realistic and organic look. So that you are well prepared, be sure to read through the instructions and refer to the step-by-step photographs before you begin to paint.

INSTRUCTIONS

1. Begin by preparing the surface and then basecoating it with the black semi-gloss latex paint using a basecoat bristle brush. (See photo 1.) Be sure that you have an even, opaque coverage. Let this layer dry thoroughly.

2. On a paint tray, prepare a light gray water-based glaze by mixing a small amount of black glaze into a puddle of white glaze. Mix well with the palette knife. Brush the gray glaze onto the surface in a random fashion with the glaze application brush. (See photo 2.) Wipe the brush on a rag or towel, and apply some patches of white glaze over the gray. Apply an ample amount of glaze to the surface. If you apply it too thinly, it will begin to set up and become tacky before you finish the technique. Move on to the next step before the glaze dries.

3. With a loosely crumpled ball of plastic wrap, begin to dab the surface. This will blend the two glazes together. Be careful not to dab too much otherwise you will overmix the glazes and create only one visible color on the surface. You want to be aware of both colors. Continue before the glazes dry.

4. Using a toothbrush, lightly flyspeck the surface with mineral spirits. (See photo 3.) Flyspecking is the technique of spritzing paint or thinner from a loaded toothbrush onto the surface, causing a paint reaction that results in a fine fossilized appearance. If you use alcohol or mineral spirits, the wet surface paint will be repelled wherever the droplets land. You must do this as soon as you have finished dabbing, or the glazes (from step 3) will begin drying and will not react to the mineral spirits. (See page 96 for more flyspecking information.) Move on to the next step before the flyspecking dries.

5. Dip a new piece of balled plastic wrap into the white semi-gloss latex paint, and dab some highlight areas onto the surface. (See photo 4.) Try to place the highlights in a diagonal direction; this will later help you establish a veining structure in the marble. You should proceed without waiting for this paint to dry.

6. Load the tip of a feather with white glaze, and then dip it into the white semi-gloss latex paint (the two paints will yield some variation of opacity and value in your veining pattern). Hold the feather like a violin bow, and lightly drag the tip across the surface of the marble. (See photo 5.) Vary the pressure as you drag, making some veins wider and others thinner or finer. Apply the veins in the same diagonal direction as the white semi-gloss latex highlights from step 5.

7. Wipe the feather on a rag or towel, and load it with black glaze. Draw some fine black veins near some of the more dominant, thicker white veins. (See photo 6.) Veins shouldn't form harsh intersections. Also, be careful not to apply too many veins, or your finish will not look natural or realistic.

8. Flyspeck the marble with both some white and some gray glaze. These small flecks of paint will add visual interest to the surface of the marble pattern.

1. Apply black semi-gloss latex paint to the surface with the basecoat bristle brush.

2. Mix some gray water-based glaze, and apply a liberal coat of it.

3. Using a toothbrush, flyspeck the surface with mineral spirits.

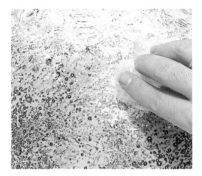

4. With a piece of plastic wrap, dab on white semi-gloss latex highlights.

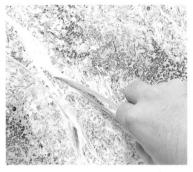

5. Using a combination of white water-based glaze and white semi-gloss latex paint on a feather, apply the white veins.

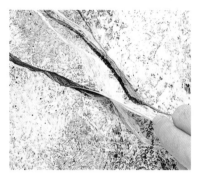

6. Apply black veins with the feather and black water-based glaze.

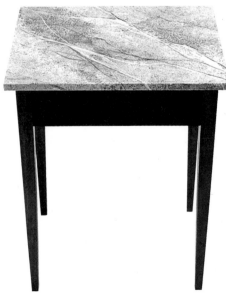

This end table combines three finishes. The top is masterfully painted with the white Carrara marble technique. The apron is painted with black semi-gloss latex paint, and the legs are stained with black water-based glaze. The practice of combining finishes works well on pieces that have clean lines.

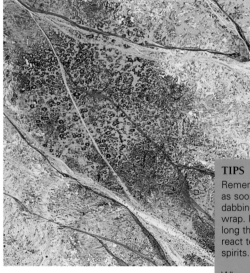

When executing the white Carrara marble finish, be sure that you can see the fossilized pattern of the flyspecking on the surface. Seeing through the finish to the basecoat (in the areas where the mineral spirits flyspecking was done) adds the illusion of depth to the marbleized surface.

TIPS
Remember to flyspeck as soon as you finish dabbing with the plastic wrap. If you wait too long the glaze will not react to the mineral spirits.

When the finish is complete, apply a gloss varnish to enhance the painted illusion and bring out the subtle variations in value. (For information on varnishing, see page 124.)

Verde Antico Marble

MATERIALS

Paints

Black semi-gloss latex paint

Seafoam green semi-gloss latex paint

Glazes

Forest green water-based glaze

Moss green water-based glaze

White water-based glaze

Brushes

Basecoat bristle brush

Glaze application brush

Miscellaneous

Paint trays

Household plastic wrap

Toothbrush

Mineral spirits

Feather

Paper towels

This is without a doubt the most popular of all painted marbles. The rich green hues complement many decors, from the casual to the very formal. This finish also works well when combined with other painted marbles, such as black and gold or white Carrara. This versatile coloration looks beautiful on tables, lamp bases, or accessories of all shapes and sizes. Don't hesitate to use it on moldings, sections of walls, floors, or virtually anywhere you choose. You can vary the look of this marble by changing the values of the green colors, or by changing the proportions of all the colors you use. If you can't find the exact same greens that I am using here, don't worry; there is great variety in nature, so chances are that you can't go wrong with your coloration. However, the basecoat should always be black, no matter what other color variations you choose.

INSTRUCTIONS

1. Begin by basecoating your properly prepared surface with black semi-gloss latex paint using the basecoat bristle brush. (See photo 1.) You might need to apply two coats in order to achieve a smooth, opaque surface on which to paint your marble. Let this dry before continuing.

2. Put some of each glaze in a separate paint tray. Using the glaze application brush, apply patches of the forest green and moss green glazes to the surface. (See photo 2.) Make sure you vary the sizes of these patches. You can put down more of one glaze than the other to suit your personal color preference. Be sure to apply the glazes liberally. If you don't, they will begin setting up (drying) before you have time to manipulate them. You want the glazes to remain workable throughout the entire marbleizing process. Move on to step 3 before these applications dry.

3. Crumple a piece of household plastic wrap into a loose ball, and blot the surface. (See photo 3.) This will blend the two colors together. When the plastic wrap becomes covered with paint, change it. Your colors will remain clearer if you change the plastic often.

4. Before the glazes dry, flyspeck the surface using an old toothbrush loaded with mineral spirits. (See photo 4.) This will cause a paint reaction and result in a fossilized pattern on the surface of the marble, revealing the black basecoat. You should flyspeck as soon as you finish dabbing with the plastic wrap; if you wait too long the glazes will set up and will not react to the mineral spirits. Move directly to the next step.

5. With a new piece of plastic wrap formed into a loose ball, pick up a small amount of seafoam green latex paint, and gently pat this color onto the surface. (See photo 5.) This will create some highlights in the marble and add a bit if color variation.

6. Continuing with the white glaze and feather, form the veining structure. Dip the tip of the feather into some of the glaze, blot the excess on a paper towel, and, using gentle pressure, create the major veins of the marble. (See photo 6.) Hold the feather loosely, and draw the veins with a "nervous" hand. Apply them in a diagonal fashion—a diagonal line is more visually pleasing and realistic than a horizontal or vertical one. After you finish the major veins, add some finer, secondary ones. Be careful not to overdo the veining. Don't put too much paint on the feather; if the veins do not show up, you can always make additional highlights on some of them.

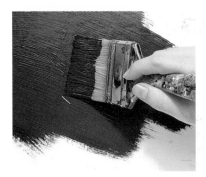

1. Apply black semi-gloss latex paint with a basecoat bristle brush.

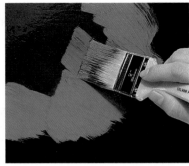

2. Apply the two green water-based glazes using a glaze application brush.

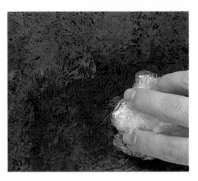

3. Dab the surface with a loosely crumpled ball of household plastic wrap.

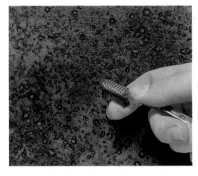

4. Flyspeck the surface with mineral spirits using a toothbrush.

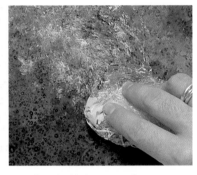

5. Dab on highlights using plastic wrap and the seafoam green latex paint.

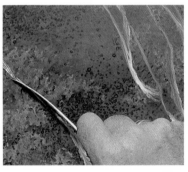

6. Using the white water-based glaze and a feather, apply the veins.

This small plant stand gains stature when its top and shelf are painted in verde antico marble. The glossy, white legs stand out in sharp contrast.

Notice the color variations in this close-up detail. You should strive to have a visible variety of greens and should be careful not to let the veining pattern be too distracting.

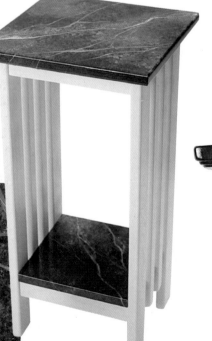

TIP
You should finish this marble with a gloss varnish to simulate the polish most often associated with verde antico marble. (See page 124 for varnishing instructions.)

This terra-cotta angel, painted with the verde antico finish, masquerades as a carved marble sculpture. The application of a gloss varnish completes the illusion.

Black and Gold Marble

MATERIALS

Paints

Black semi-gloss latex paint

Metallic gold artists' tube acrylic

Pearlescent gold artists' tube acrylic

Black artists' tube acrylic

White artists' tube acrylic

Brushes

Basecoat bristle brush

Synthetic-bristle flat brush

Natural-bristle fan brush

Miscellaneous

Palette knife

Paint trays

Water

Natural sea sponge

Paper towels

Toothbrush

Characterized by its unique and bold surface, black and gold marble is among the most dramatic faux finishes you can create. The breccia (chunks of black rock) appear to be floating in a sea of gold. The secret to the success of this marble finish is in the placement of these breccia. The technique is challenging, but because you must allow for drying time between each step, you can work slowly and achieve beautiful results. Since the pattern is extremely busy, you should use this marble on small accessory pieces or furniture. If you want to use it on walls or floors, make sure to use it sparingly; too much tends to be overwhelming and distracting. While on some of the other marble finishes you can alter the colors, this is a specific type of marble that is always executed in black and gold.

INSTRUCTIONS

1. Using the basecoat bristle brush, basecoat the surface using black semi-gloss latex paint. (See photo 1.) If it is necessary to achieve a smooth, opaque covering, apply two coats, letting the first one dry completely before applying the second. Let this basecoat dry thoroughly.

2. Using a palette knife for mixing, dilute the two shades of gold paint with water (each in a separate paint tray) until they are both a thin, soupy consistency.

3. Moisten the sea sponge with water, and wring out the excess. Dip it into one gold and then the other. Do not mix the two golds together—you want to see both colors. Drag the sponge across the surface in a crisscross manner without applying too much pressure. (See photo 2.) You should only cover approximately 90% of the surface with gold; if you put too much pressure on the sponge, it will flatten out and leave a solid covering of color on the surface. You want to let some of the black show through the crisscross pattern. Let this dry before proceeding.

4. Using the flat brush and the black acrylic paint, begin to paint the breccia shapes. (See photo 3.) Vary the size and shape of the breccia, first concentrating on creating the large shapes and then filling in the remainder of the surface with smaller breccia.

5. In a clean paint tray, mix a dark gray color from the black and white acrylics, and paint some small breccia with it. These shapes should not be too light in color value or they will be very distracting. You want all of the larger breccia to be dark, with the gray breccia adding a very subtle visual interest. Also add some small dots of white scattered in between the black and gray breccia. Let the surface dry completely.

6. At this point, you are ready to add the fine, striated markings to the breccia. Dilute some white acrylic paint with water (in a clean tray) until it is a very thin, flowing consistency, and pick it up on the fan brush. Blot the excess on a paper towel. Separate the bristles with your fingers, and, using no pressure, drag the brush across the large breccia. (See photo 4.) Only make striations on the bigger shapes. Remove any unwanted or stray markings immediately with a damp paper towel. If the markings appear too heavy, thin your paint a bit more, and blot more off your brush. The markings should be very fine, almost scratchlike. Allow this layer to dry.

7. Dilute some black acrylic paint with water (in a clean tray) until it is a thin, flowing consistency, and, using a toothbrush, flyspeck the surface with this mixture. (See photo 5.) This will soften the overall appearance of the marble and tone down the brightness of the white markings.

 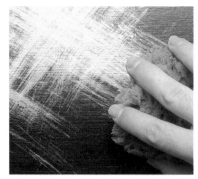 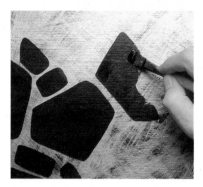

1. Apply black semi-gloss latex paint with a basecoat bristle brush.

2. Using a sea sponge, apply the gold tones that will form the background of the marble finish.

3. Paint the large breccia with a flat brush and black acrylic paint.

TIPS
Remember: Do not cover the entire background with gold. Having the black shine through adds dimension and interest.

If there are any areas that appear too light or that you don't like, simply add more flyspecking to them. Flyspecking will tone those areas down and disguise any flaws that might be in them.

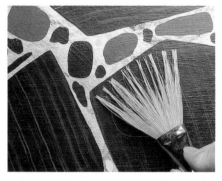 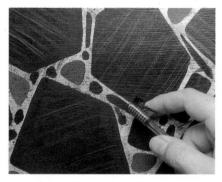

4. Using diluted white acrylic paint on a fan brush, apply the fine, striated markings to the breccia.

5. Using a toothbrush, flyspeck the entire surface with thinned black acrylic paint.

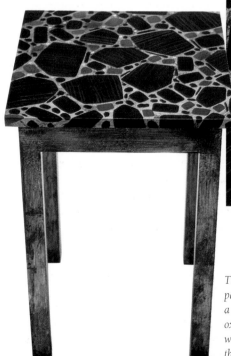

The black and gold marble pattern is very active. Notice the variety of breccia shapes, the subtlety of the gray breccia, and the striations on the larger forms.

This small end table has been given the royal treatment. I painted the top with black and gold marble and finished it with a high-gloss varnish. I basecoated the apron and legs with red oxide, gilded them with gold foil leaf, and then antiqued them with a black water-based glaze. (These techniques are covered thoroughly on pages 80 and 116.)

Norwegian Rose Marble

MATERIALS

Latex Paints
White semi-gloss

Artists' Tube Acrylic Paints
Iridescent green
Burnt umber
Ultramarine blue
Ivory black
Titanium white
Alizarin crimson
Bright red
Silver

Brushes
Basecoat bristle brush
Glaze application brush
1" square wash brush
#10 flat brush

Miscellaneous
Paint trays
Palette knife
Water
Acrylic retarder
Toothbrush
Rubbing alcohol
Household plastic wrap

The pinks and grays of this brecciated marble make it one of the most appealing stones to simulate. This finish is painted in multiple layers, making it easy for you to create interest and drama. Rose marble is traditionally used for tabletops, but don't limit yourself to this one surface. Try it on boxes and other accessories. If you work methodically, you will have no trouble painting a marble that will truly fool the eye of the beholder. If you cannot find these exact colors, just pick similar ones, but try to stick with these color families.

INSTRUCTIONS

1. To begin, apply a basecoat of the white semi-gloss latex paint to the prepared surface using the basecoat bristle brush, and allow it to dry completely. (See photo 1.) You must have smooth, opaque paint coverage; if necessary, apply a second coat, and let this dry, too.

2. On separate paint trays and using the palette knife for blending, mix a dark gray-green color from the iridescent green, burnt umber, ultramarine blue, and ivory black, and a light pink hue from the titanium white, alizarin crimson, ivory black, and bright red. Be sure to mix a large amount of both colors because you will use them throughout the painting process. Dilute a portion of these paint mixes with equal parts of water and acrylic retarder until they are soupy and somewhat transparent in consistency; these mixtures are what you will use for painting. Save the rest of the undiluted paint in case you run short and need to dilute more.

3. Using the glaze application brush, wet the surface with equal amounts of water and acrylic retarder. Do not allow any puddles to form on the surface; you simply want to dampen it.

4. While the surface is wet, brush streaks of the gray-green and pink mixtures onto it using the glaze application brush. To avoid muddying your paints, always rinse your brush in some water before switching colors. Do not put too much color on the surface when you begin. Norwegian Rose marble has a soft and subtle coloration. You can always add more color if need be, but removing it is difficult.

5. While the paint is still wet, use the toothbrush to flyspeck the entire surface with rubbing alcohol. Since you're using alcohol, the wet surface paint will lighten (or be repelled) wherever the droplets land. (See page 96 for flyspecking information.) Be sure you flyspeck with the alcohol as soon as you finish applying the paint streaks. If too much time elapses, the paint will dry, and the alcohol will not lighten it. Go on to the next step before this dries.

6. Dab the surface with a loosely crumpled ball of plastic wrap to create some texture. (See photo 2.) This will move the paint around on the surface and result in interesting "fossilized" areas in your finish. Let the paint dry at this point.

7. With the 1" square wash brush, strengthen some of the paint streaks. Do not strengthen the streaks over all areas of the marble pattern, just in some parts. (See photo 3.) If the color seems harsh, blot it with some plastic wrap, and then move on to the next step *before* the paint dries.

8. You are now ready to begin forming the breccia pattern of the Norwegian rose marble. As mentioned briefly in the section on black and gold marble, breccia are rock fragments that are embedded in a fine-grained matrix and form a distinct design. Breccia shapes are irregular and, in this marble, long and

jagged in appearance. The first stage in forming this pattern is to remove any color where you want the breccia to eventually be. To do this, dip the #10 flat brush into water and begin to scrub out your breccia shapes in the paint, which should still be damp. (See photo 4.) As you scrub, you might find that some of the color moves to the edges of your shapes; do not be concerned as this will add interest to the finished marble pattern. You might need to apply quite a bit of pressure to the surface in order to remove the paint, but be patient—the paint will eventually loosen and come off. If the paint is very stubborn, dip your brush into some rubbing alcohol, and try scrubbing again. Wait for the paint and any alcohol to dry.

9. Flyspeck the marble using paint. Loading the toothbrush with the appropriate color, spritz the gray-green mixture over the areas that have more gray and the pink mixture over the areas with more pink. Note that when you flyspeck with paint, as opposed to with alcohol, you are applying additional color, rather than repelling parts of a previous paint application. Wait until this is almost dry.

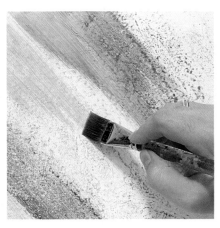

1. Prime the surface with a basecoat of white semi-gloss latex paint using the basecoat bristle brush.

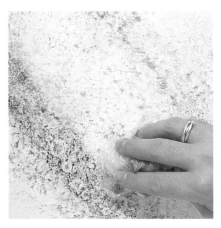

2. After applying the gray-green and pink mixtures with the glaze application brush (making sure to leave some white spaces) and flyspecking the surface with alcohol, dab it with a piece of household plastic wrap.

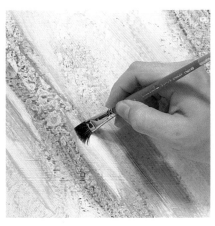

3. Strengthen some of the gray-green and pink streaks with further paint applications, using the 1" square wash brush.

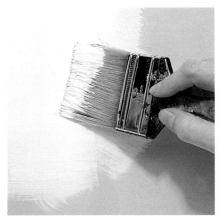

4. Begin to make the breccia shapes with the #10 flat brush. If necessary, use a little alcohol to expedite the process.

10. In a clean tray, dilute some silver paint with water and acrylic retarder until it is a transparent wash, and then apply it to some sections of the marble with the glaze application brush. (See photo 5.) This will add a nice pearlescent quality to the surface. As you become more familiar with this technique, you will discover just how much water and retarder makes the best wash; until then, just add small amounts of each, a little at a time. Let this silver wash dry before you continue.

11. Highlight outer edges of the breccia using some white paint and the #10 flat brush. (See photo 6.) You can move directly to the next step.

12. Using the toothbrush, flyspeck the entire marble surface with the thinned silver paint. This flyspecking will be most evident on the white areas of the finish. Let this dry.

13. For interest, add some dark areas to the marble. To do this, load the 1" square wash brush with water and retarder, and dip one corner of it into the gray-green color. Stand the brush on its bristle end, and gently tap the paint onto the surface next to some of the breccia. (See photo 7.) Apply more of this dark color to the darker areas of your pattern. If there is enough moisture in the brush, small, irregular puddles of paint will form on the surface and dry into organic-looking pits in the marble.

14. With the #10 flat brush, add final highlights to some of the breccia using more white paint. Try to place these highlights next to the darkest dark areas. (See photo 8.) They will provide contrast in the marble pattern.

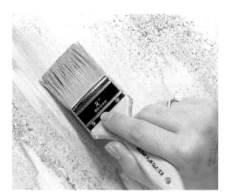

5. Apply a wash of silver to the surface with the glaze application brush.

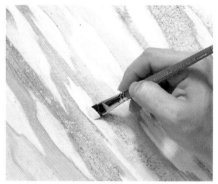

6. Highlight the outer edges of the breccia with white using the #10 flat brush.

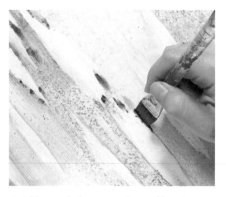

7. Add some dark areas to the marble using a wash brush loaded with retarder and water then dipped in gray-green paint. Hold the brush upright and tap it gently against the surface.

8. With the #10 flat, apply additional white highlights to the edges of some of the breccia.

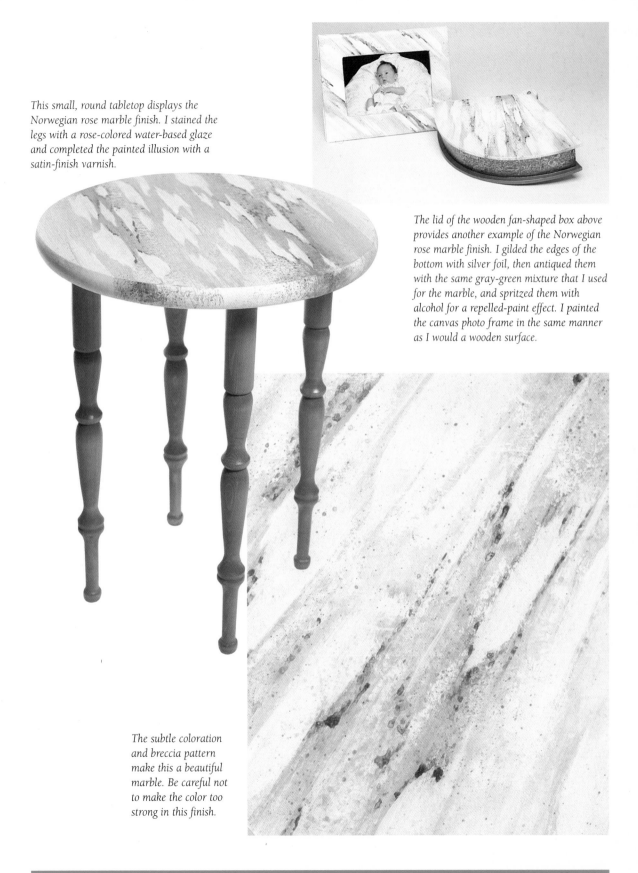

This small, round tabletop displays the Norwegian rose marble finish. I stained the legs with a rose-colored water-based glaze and completed the painted illusion with a satin-finish varnish.

The lid of the wooden fan-shaped box above provides another example of the Norwegian rose marble finish. I gilded the edges of the bottom with silver foil, then antiqued them with the same gray-green mixture that I used for the marble, and spritzed them with alcohol for a repelled-paint effect. I painted the canvas photo frame in the same manner as I would a wooden surface.

The subtle coloration and breccia pattern make this a beautiful marble. Be careful not to make the color too strong in this finish.

FAUX BOIS

Faux bois means "false wood" in French. Faux bois is a popular decorating technique that can turn an ordinary surface into a sumptuous, exotic wooden piece. It is perfect on interior woodwork and furniture, or any accessory, and is suitable for wood or any other type of surface material, such as ceramic, plaster, and even tin.

Satin Wood

MATERIALS

Paints
Cream semi-gloss latex paint
Raw sienna artists' tube acrylic
Raw umber artists' tube acrylic
Black artists' tube acrylic
Burnt umber artists' tube oil color
Asphaltum artists' tube oil color

Glazing Mediums
Clear, oil-based glazing medium

Brushes
Basecoat bristle brush
Glaze application brush
Fan brush

Miscellaneous
#400 grit sandpaper
Paint trays
Acrylic retarder
Water
Palette knife
0000 steel wool (this is a fine grade)
Cotton rags

Faux bois is generally composed of three layers. The first layer is the pore structure, which is a pattern in the wood (independent of the grain pattern) that is more noticeable in less distinctly grained woods, like oak. The second is the grain pattern, and the third is the toning, or color, level. Different wood will have different characteristics. For example, oak has a definite pore structure whereas burl walnut does not. You must look at the actual wood to study the different layers and determine which characteristics you want to be more dominate.

For this satin-wood finish, I chose to have the pore and toning level be more dominant and to keep the grain layer very subtle. I suggest that you stick with these, or very similar, colors for this technique.

INSTRUCTIONS

1. Prepare the surface properly, and basecoat it with the cream-colored semi-gloss latex paint. I prefer to use the basecoat bristle brush because it allows for ease and uniformity of application. (See photo 1.) Let the first coat dry, and sand it lightly with the #400 sandpaper. Apply a second coat, and let this dry as well.
2. Mix equal amounts of the raw sienna and raw umber acrylics in a paint tray, and add some acrylic retarder to this. Add enough water to make the mixture soupy and transparent. The amounts of retarder and water that you add depend on the amount of paint you are using; if you are unsure, just add a little bit of each at a time. You want the color to be transparent but not like dirty dish water. Mix this well with the palette knife.
3. Unroll the steel wool pad, and retwist it until it looks like a long sausage. Then, twist it back on itself like a rope. Put this aside for the time being.
4. Load the glaze application brush with your thinned paint mixture, and apply this to the surface. Brush the paint on liberally so that it will dry slowly and you will have time to work. Go to step 5 without waiting for the paint to dry.
5. Take your steel wool, and drag it through the paint. (See photo 2.) This creates the pore structure. The steel wool will make the paint streaky with, hopefully, a few "pulls" in it that will add to the realistic wood grain look. Do not be concerned if your hand shakes as you put down the grain lines; the finish will look a bit more realistic if it isn't too perfect. To achieve a richer color, repeat this step, and then touch the steel wool to the surface in some spots. This will create some details ("crossfire" marks) on the grain pattern, which are indicative of cross-cutting (or splitting) the piece of wood. Allow this step to dry.
6. In a paint tray, prepare a mixture of the raw sienna, raw umber, and black acrylics. You will only need a little black to deepen the color. Blend them well with the palette knife. Load the fan brush with this mixture, separate the bristles with your fingers, and carefully pull the brush across the surface. This will create a more definite grain pattern. (See photo 3.) Let this application dry completely.
7. Tint some of the clear, oil-based glazing medium with burnt umber plus asphaltum oil colors in another paint tray. Brush this glaze on the surface with the glaze application brush, and then remove it by gently wiping it with a soft cotton rag. (See photo 4.) This is very important to the overall look of the grain pattern. Without the glaze the wood will look dull and drab. The richness of the oil color brings out the subtle coloring and imparts a look of warmth to the finish. To add more interest to the wood grain pattern, hit the surface with a crumpled rag. Leave some of the rag marks showing for variety.

1. Basecoat the surface with the basecoat bristle brush using the cream semi-gloss latex paint.

2. Drag the steel wool through the paint to create the pore structure.

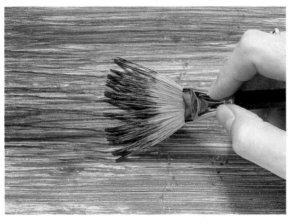

3. Add the grain pattern using the fan brush.

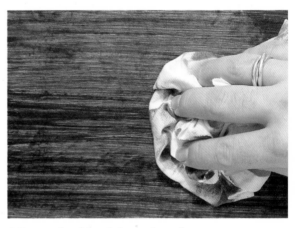

4. Remove the oil-based glaze with a soft cotton rag.

Satin-wood graining dresses up this plain wooden tissue box. I applied the grain vertically, but for a different look, you could create a diagonal grain pattern.

Ebony Wood

MATERIALS

Paints

Cream semi-gloss latex
paint

Burnt umber artists' tube
acrylic

Alizarin crimson artists'
tube acrylic

Black artists' tube acrylic

Burnt umber artists' tube
oil color

Asphaltum artists' tube oil
color

Glazing Mediums

Clear, oil-based glazing
medium

Brushes

Basecoat bristle brush

Glaze application brush

Miscellaneous

Paint trays

Palette knife

Acrylic retarder

Water

Feather

Toothbrush

Cotton rags

This dark wood-grain finish has a mysterious air about it. It lends itself well to a variety of furniture, woodwork, and accessory applications, and can be applied to any surface material. You can also combine it with gilding and marbleizing techniques, and if you use it with the satin-wood finish, you can create beautiful marquetry (inlaid wood) effects of different colorations.

INSTRUCTIONS

1. Prepare the surface, and apply two coats of the cream-colored semi-gloss latex paint with the basecoat bristle brush. (See photo 1.) Let the application dry before continuing.

2. In a paint tray, mix the burnt umber, alizarin crimson, and a small amount of black acrylic paints to make a dark brown color. Blend them well with the palette knife. Add acrylic retarder and water until this is a nice, soupy consistency. As with the satin-wood technique, the amounts of retarder and acrylic depend on the amount of paint. You could try using one part retarder to three parts water, but it is best to just experiment and add a little bit of each at a time until you get a good consistency.

3. Using the glaze application brush, apply this mixture to the surface in the direction in which you want the grain to run, and let it dry. (See photo 2.) Apply a second coat of this transparent paint to deepen the color of the wood finish, and let this dry, too. (Note: You might need to apply the paint several times in order to get a rich, dark appearance in the finish.)

4. Thin some black acrylic paint with acrylic retarder and water in a separate paint tray. Add some of the dark brown color that you made in step 2 to this mixture.

5. To create the grain pattern, load three or four inches of one side of the feather with this darker paint mixture. Drag this along the edge of the paint tray to remove excess paint. Following the direction you established with the original paint application in step 2, drag the feather across the surface. (See photo 3.) This will create an interesting pattern. You can go over an area again and again until you achieve a good pattern. Note that as you apply the these grain lines, you may need to continually reload the feather with paint. Also, be sure to create some areas that have more grain pattern and others that have less. When you are finished, move directly on to the next step.

6. Dilute some more black acrylic paint with water and, using a toothbrush, flyspeck the surface, adding even more interest. Allow this to dry completely.

7. Tint some clear, oil-based glazing medium with burnt umber and asphaltum oil colors. Blend with the palette knife. Use your glaze application brush to apply this glaze to the surface, and then remove it by gently wiping with a soft cotton rag. (See photo 4.) To add some more interest to the wood grain, hit the surface with a crumpled rag, and leave some of the rag marks showing for variety.

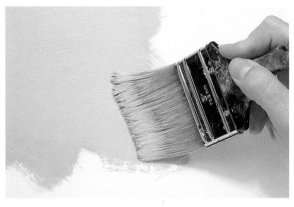

1. Apply the cream semi-gloss latex basecoat with the basecoat bristle brush.

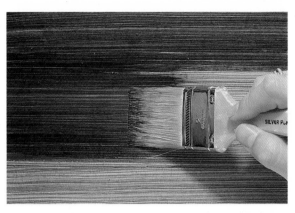

2. Apply the dark, wood-tone paint with the glaze application brush in the direction that you want your grain pattern to go.

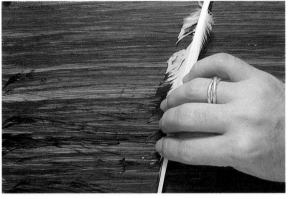

3. Add the grain lines by using a feather loaded with the darker thin, blackish paint mixture.

4. Remove the excess oil-based glaze with a cotton rag.

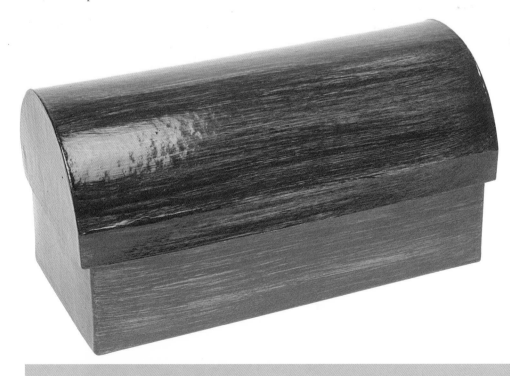

You could never tell that this chest is actually made of papier-mâché. The ebony faux bois finish gives the illusion that it is made of real wood.

METAL AND FOIL LEAF

The luster of gold and silver has been coveted for centuries. There is no denying the beauty of precious metals. Whether used on the onion dome of a Russian cathedral, the throne in a European palace, or even a modest picture frame in your home, metal leaf is unmatched in its beauty and brilliance.

The addition of metal leaf, or imitation foil, instills a touch of class or elegance to any surface. You can use it as trim on furniture or accessory pieces. For interiors, you can make grand rooms even more spectacular by gilding moldings, column capitals, or even ceilings. You can even combine gilding with other paint finishes for a more dramatic look. For example, it works very well as a trim or background with marbleizing, texturizing, or any decorative painting. The techniques for gilding are the same for any type of metal leaf, be it gold, silver, or copper, and the effort you spend learning to properly gild a surface will be rewarded time and time again.

Applying Metal Leaf

MATERIALS

Paints
Red oxide semi-gloss latex paint

Metal Leaf and Sizing
Oil-based gold leaf size (adhesive)

Imitation gold, silver, or copper leaf

Brushes
Basecoat bristle brush

1"-wide poly brush

Soft blending brush

Red-sable flat brush

Varnish application brush

Miscellaneous
Scissors

Soft, lint-free cotton cloth

Gloss varnish

Waxed freezer paper (optional)

You can apply metal leaf to any rigid surface: metal, wood, terra-cotta, and even papier-mâché. All metal leaf is applied using the same technique, which takes a bit of time. This is true for gold, silver, copper, and variegated leaf. The metal leaf that is most commonly used today is imitation gold leaf. Although real gold leaf is still available, it is very cost prohibitive. I only use it when the occasion calls for it— for example, on a very special piece of decorative painting or a wonderful furniture piece. Although real silver leaf is also available, most silver leaf is actually aluminum. Copper leaf is always real. Most likely, you will find that metal leaf looks too bright without some other paint finish over it to tone it down. You can use antiquing or texturizing for this purpose, and, with the exception of silver leaf, it doesn't matter whether you use oil- or water-based paints and glazes. For silver leaf you should always use an oil-based glaze.

Both real and imitation metal leaf comes packaged in books of 25 sheets, approximately 4 x 4" each. These books are available at art supply and craft stores. Each sheet is separated by a piece of tissue. Do not remove a sheet of leaf from the book until you are about to use it. The sheets are so thin and fragile that your breath can break one and scatter the pieces. Try to work in a draft-free area when you are leafing.

INSTRUCTIONS

1. Properly prepare the surface. Take care when preparing material for metal leafing because any flaws in the surface will show through the leaf. If you invest the time to properly prepare the surface, you will be greatly rewarded when you complete your project. Apply two coats of red oxide semi-gloss latex paint with the basecoat bristle brush. (See photo 1.) Red oxide is the traditional color used for gold leaf because it is a good, rich hue that looks nice with the gold. With real gold leaf, the red oxide color helps give thin gold sheets depth and added richness. (For silver leaf, use a dark green or black basecoat; for copper leaf, use red oxide or brown.) Let this basecoat dry before continuing.

2. With the 1" poly brush, apply a thin coat of gold leaf size. The metal leaf will only adhere to the surface where you apply the size, so be sure to check that you have not left any areas free of size. (See photo 2.) Allow the size to reach the proper tack (the necessary degree of stickiness to be ready to receive the leaf). This should be between one and eight hours. Follow the manufacturer's directions on the label.

3. Once the size is at the proper tack, you are ready to apply the metal leaf. Most often the sheets of leafing are larger than you need, so you will have to cut the leaf to a more manageable size with a pair of scissors. You'll also have to cut all the sheets together, since they are too fragile to cut one at a time. *Do not remove the leaf from the protective tissue to cut it.* Once cut, fan the edge of the book to loosen the sheets of leaf; this will separate the edges of the sheets, which get mashed together when you cut them. Gently and carefully pick up one sheet of leaf (with its protective tissue underneath), and move to the surface you are leafing. Gently lay the leaf on the surface. To do this, touch the edge of the sheet to the surface, and slide the tissue out from under it. (See photo 3.) Chances are, if it is your first attempt at leafing, the leaf will crumble or tear as you lay it down. Don't be discouraged; you'll get the hang of it—it just takes time.

4. Place the piece of tissue over the leaf and, with the soft blending brush, gently brush the tissue. (See photo 4.) This will press the leaf into the tacky size. Make sure the tissue is covering the leaf before you brush it; metal leaf is very fragile, and the tissue will prevent the brush from scratching it.

5. Continue to apply pieces of leaf until the surface is covered. For an added measure of caution once you are done, place a piece of tissue paper over the entire surface and brush it again with the sable brush to be sure that all the leaf is in contact with the size. If the leaf is not pressed into the size, it might come off during the burnishing stage. Let the leafing dry overnight. It is very important not to rush this process.

6. To remove the excess leaf, you must burnish the surface. Remove all tissue paper, and with the sable brush, gently brush the length of overlapped leaf seams; any leaf that did not adhere to the sizing will brush off. Save these scraps, called skewings, since you can use them in another gilding technique (see page 88) or to fill in gaps as you are leafing other projects. When burnishing or polishing the metal leaf, do it gently; it is very delicate and can be easily scratched.

7. Once you brush away the excess leaf, use a soft, lint-free cotton cloth to gently rub the surface in a circular manner. (See photo 5.) This will remove the tiny particles of leaf that remain on the surface.

8. The leaf is still very delicate at this stage. Oils from your skin can tarnish it. To protect the leaf, you must apply a coat of gloss varnish (with a varnish application brush). To prevent tarnishing, varnish the metal leaf as soon as you finish burnishing it. (See photo 6.) Now the leafing is complete. Again, in most cases metal leaf is too garish without some toning applied over it. Many effects are beautiful on metal leaf, including antiquing, texturizing, and solvent flyspecking.

1. Basecoat the surface with semi-gloss latex paint. (I use red oxide paint here because I'm using gold leaf.)

2. Put down the sizing with the poly brush, and let this application reach the proper tack.

3. Apply the sheets of metal leaf to the sticky surface.

4. Protecting the leaf with tissue, press it into the surface with a soft blending brush.

5. When the leaf is dry, burnish it with the sable flat brush to remove the excess. Then, polish with a soft cotton cloth.

6. Apply a coat of gloss varnish to seal and protect the fragile metal leafing.

SILVER LEAF

Silver leaf is applied using the process described on the previous two pages, and the skill level is the same. Most silver leaf used today is aluminum leaf. If you use genuine silver leaf, be careful not to touch it with your hands; the silver tarnishes *very* quickly when you handle it. You should varnish silver leaf only with *oil-based* varnish as the moisture in water-based varnish can cause a tarnishing reaction with genuine silver leaf. As with gold leaf, the silver looks too garish without an overlying finish, like texturizing.

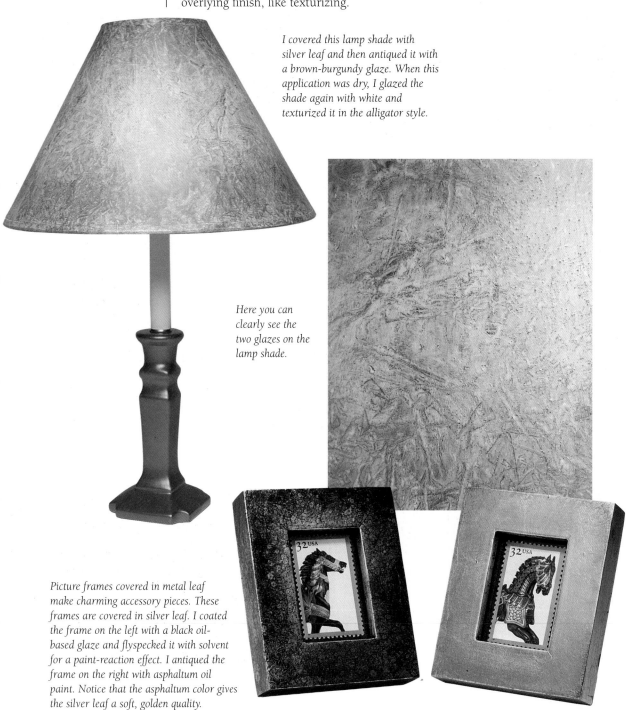

I covered this lamp shade with silver leaf and then antiqued it with a brown-burgundy glaze. When this application was dry, I glazed the shade again with white and texturized it in the alligator style.

Here you can clearly see the two glazes on the lamp shade.

Picture frames covered in metal leaf make charming accessory pieces. These frames are covered in silver leaf. I coated the frame on the left with a black oil-based glaze and flyspecked it with solvent for a paint-reaction effect. I antiqued the frame on the right with asphaltum oil paint. Notice that the asphaltum color gives the silver leaf a soft, golden quality.

VARIEGATED LEAF

Variegated leaf is usually gold leaf that is oxidized in some way. The leaf comes this way in the package and is available in red, green, and black varieties. Variegated leaf is beautiful and unusual, but too much of it can be very busy and distracting. For application, follow the steps on page 80.

It is easy to give any plain object a little embellishment with metal leaf. Here, I placed a strip of variegated gold leaf on the cover of a notebook. If you feel that completely covering an object with leaf would be too garish, you can strategically place pieces of it in small areas.

This tray was the perfect surface for variegated gold leaf. The broad, flat center area shows off the unusual pattern in the leaf, and the look is boldly elegant. I left the leaf unantiqued because I liked the bright color and pattern, but you could tone down the effect.

I covered this carved tray with sheets of metal leaf and then antiqued it. The antiquing collects in the grooves and adds interest. (See page 116 for antiquing instructions.)

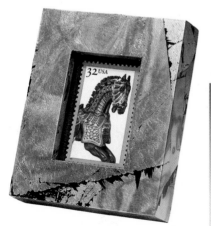

I covered this frame with black variegated gold leaf. There is no antiquing over it.

After gilding these frames, I antiqued the frame on the left with burnt umber and asphaltum oil paint colors and texturized the frame on the right with a burnt umber- and asphaltum-colored oil-based glaze in the alligator style.

Patinas for Copper Leaf

MATERIALS

Unvarnished copper-leafed surface
Paint tray
Liver of sulfur
Water
Natural sea sponge
Paper towels
Oil-based semi-gloss varnish
Varnish application brush

Copper leaf is very bright and garish if not toned down in some way. These are two methods that will add rich patinas to copper-leafed surfaces. These patinas *do not* work on imitation gold or silver leaf, and you must execute them on the leaf surface before you varnish it. (Follow the application steps on page 80 for applying the leaf.)

OXIDIZED COPPER

This patina results in a mottled, darkened, blackish and bluish pattern over the copper leaf. It is unusual and mellow in appearance yet still allows the richness of the copper leaf to remain visible.

INSTRUCTIONS

1. In a paint tray, dilute the liver of sulfur with water at a 1:1 ratio. In general, you don't need much of this mixture. Moisten the sea sponge with water, and wring out the excess.

2. Rub the damp sponge over the surface of the copper leaf to dampen it, leaving some puddles of water. Dip the corner of the sponge in the diluted liver of sulfur, and gently dab it on the surface. You should instantly see a darkening of the copper. (See photo 1.) If the copper turns black, you need to dilute the liver of sulfur some more. The trick is to have the copper turn several different shades of bluish and blackish colors. Once this reaction takes place, blot the surface with a paper towel to remove any excess moisture. Note that if the liver of sulfur is too strong (not diluted enough) and the piece does turn black, you can rescue it by rubbing it vigorously with a damp paper towel. The copper won't become bright again, but it will regain some luster. Let this dry before proceeding.

3. Once you oxidize the entire surface (see photo 2), varnish it to seal and protect the leafing. Use an oil-based semi-gloss varnish and a varnish application brush, or spray with clear acrylic spray.

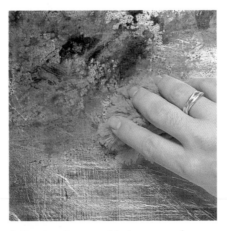

1. Dampen the unvarnished copper surface with water, and then blot it with a sponge moistened with the diluted liver of sulfur solution.

2. The oxidation takes place immediately.

The background behind this folk art rooster-and-heart painting is oxidized copper leaf, which shows the effects of liver of sulfur. It adds an unusual touch to a traditional, dry-brush design.

The copper leaf on this frame takes on a mellow and rich look after being oxidized. I brushed the edges of the frame with more liver of sulfur to make them black.

MATERIALS

Unvarnished copper-leafed surface

Cider vinegar

Spray mister bottle

Table salt

Paper towels

Oil- or water-based satin-finish varnish

Varnish application brush

VERDIGRIS

This technique produces an attractive random, mottled, greenish and reddish pattern on the copper-leaf surface. Like oxidized copper patina, it is easy to do and adds interest to any piece.

INSTRUCTIONS

1. Fill the spray mister bottle with cider vinegar, and spritz the surface of the leafing fairly heavily.
2. Shake the table salt on the wet surface. (See photo 1.) Cover with a paper towel and wait.
3. When the paper towel is dry, remove it; you should see a lovely greenish blue patina on the copper leaf. (See photo 2.) Don't be concerned if some of the copper leaf has been eaten away by the caustic properties of the patina reaction. This adds charm to the piece. (If you do not want to risk the copper leaf being eaten away in places, use two layers of leaf: apply one layer and burnish it with a cotton cloth, omitting varnish. Next, apply gold leaf size and add a second layer of copper leaf. Then start with the verdigris finish.)
4. Varnish the piece. You can use either a spray- or a brush-on varnish; if you choose brush-on, use a varnish application brush. A semi-gloss or satin finish is most appropriate.

1. After spritzing the surface with cider vinegar, sprinkle on the table salt.

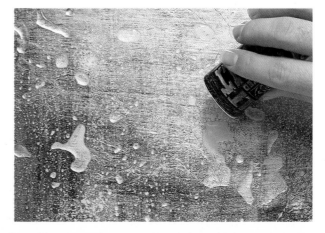

2. When the vinegar and salt dry on the surface, a beautiful chemical reaction takes place, leaving a wonderful patina on the copper leaf.

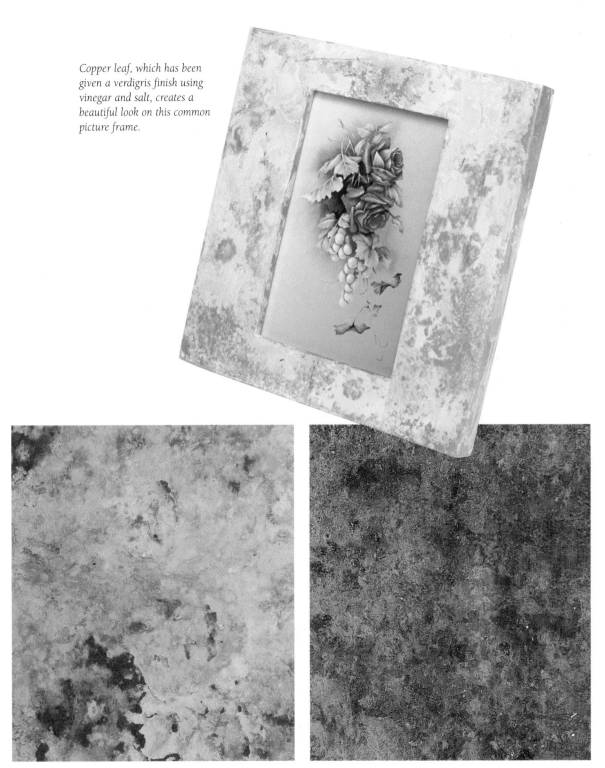

Copper leaf, which has been given a verdigris finish using vinegar and salt, creates a beautiful look on this common picture frame.

This is a detail of verdigris finish on copper leaf.

This is the same finish as shown at left, but it has been antiqued with an oil-based glaze made from burnt umber and Prussian blue oil colors.

Working with Skewings

MATERIALS

Paints

Semi-gloss latex paint (any color)

Brushes

Basecoat bristle brush
Poly brush
Sable flat brush
Soft blending brush
Varnish application brush

Miscellaneous

Gold leaf size
Skewings
Waxed freezer paper
Soft cotton cloth
Gloss varnish

To create a different and exciting look with leaf, you can use skewings (the scraps collected from the burnishing process). Skewings add a dramatic touch when used on decorative accessories or on any surface where a solid application of leafing may be too much. They are also lovely when combined with areas of solid leaf.

INSTRUCTIONS

1. Prepare the surface, and apply a semi-gloss latex paint in a color of your choice with the basecoat bristle brush. (See photo 1.) I used a dark, dull green here. Keep in mind that this base color will be a dominant feature in the finished look. Let this dry before continuing.

2. Using the poly brush, apply the gold leaf size over the entire area on which you plan to put the skewings, and allow it to dry almost to the end of the manufacturer's recommended working time (see label instructions). The surface should be just barely tacky. (See photo 2.)

3. Pick up some of your skewings with the soft sable flat brush, and gently guide them to the surface. Let them fall into place. You will have only moderate control of where the skewings land; the more random the pattern the better. Once the skewings land on the surface, gently brush them into place with the sable brush. Continue applying skewings until you cover the surface to your liking.

4. Take a piece of waxed freezer paper and place it on the surface, waxy side down. Using a soft blending brush, brush over the surface to make sure that the skewings are secured in place. (See photo 3.)

5. Let the piece dry overnight. Burnish as usual. (See page 81 for burnishing instructions.) You may need to spend some extra time burnishing the skewings with the soft cloth because the skewings are crunched clumps of leaf that are folded over themselves, and you must take care that you remove all the loose wads from the surface.

6. Using the varnish application brush, coat with a gloss varnish. (See photo 4.)

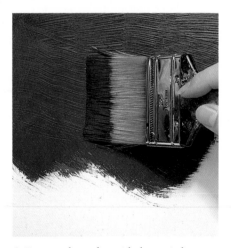

1. Basecoat the surface with the semi-gloss latex paint. (Remember, you can use any color you like.)

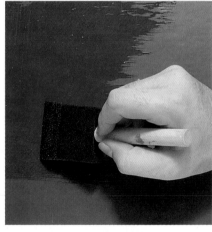

2. Apply the sizing and wait for it to become tacky. Follow the manufacturer's time recommendation.

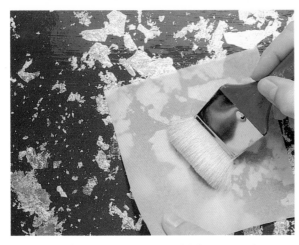

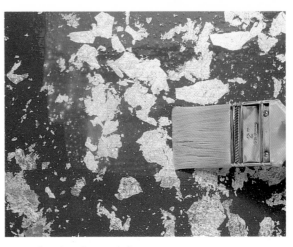

3. Using a soft blending brush, secure the skewings in place.

4. Finish with a gloss varnish.

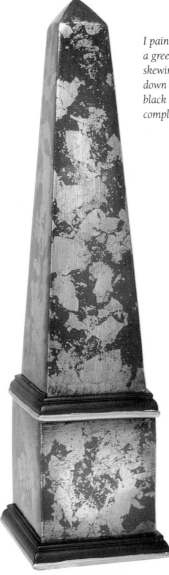

I painted this plaster obelisk in a green color and covered it with skewings. Umber antiquing tones down the bright gilding, and black and gold painted trim completes the piece.

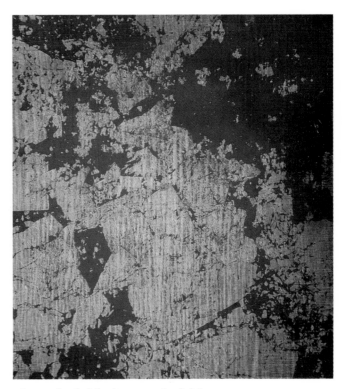

This is a detail of the skewing on the obelisk.

Applying Foil Leaf

MATERIALS

Paints
Red oxide semi-gloss latex paint

Brushes
Basecoat bristle brush
1" square wash brush

Foil and Adhesive
Foil adhesive
Gold foil

Foil leaf is a nice substitute for metal leaf if you are in a hurry or just don't want to work with metal leaf. Foil leaf is a metallic substance that is backed with a clear plastic sheet. The foil comes on a roll, is very easy to use, and is available in both gold and silver. Like metal leaf, foil is very bright and garish, and must be toned down in order to be attractive. Use it on furniture, accessories, or anywhere that you would use metal leafing. For this demonstration, I'm using gold foil with a red oxide basecoat.

INSTRUCTIONS

1. Apply the red oxide semi-gloss basecoat with the basecoat bristle brush, and let it dry. (See photo 1.) If the first coat is not opaque, apply a second one, and let this dry, too.
2. With the 1" square wash brush, apply the foil adhesive. The adhesive will be milky in appearance when it is wet. (See photo 2.) As it dries, it will become clear.
3. When the adhesive is clear and still sticky, press a piece of foil into it, dull side down. Rub firmly with your hand. This will release the foil from the plastic backing sheet. After you rub the entire back of the piece of foil, pull the plastic sheet way from the surface. (See photo 3.) If there are places that are not covered, simply place some more foil over the area and rub; the foil will only stick where the adhesive is still exposed. If the adhesive dries before you finish, simply apply more. Continue to place the foil over the surface. (See photo 4.) Don't worry if some areas remain uncovered; they will add an antique quality to the finish and will become integrated when the foil is toned down.
4. When you finish applying the foil, tone it down with any of the techniques described in the book. You can use both oil- and water-based paints for this. Texturizing and antiquing look especially lovely over the foil.

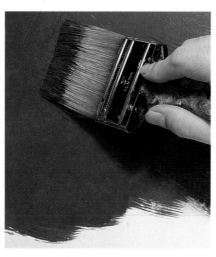

1. Basecoat the surface with semi-gloss latex paint using a basecoat bristle brush.

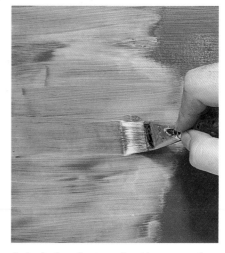

2. Apply the adhesive with a 1" square wash brush.

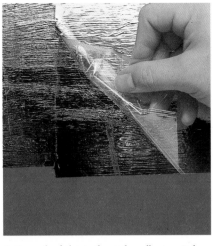

3. Press the foil into the sticky adhesive. Rub with your fingers, and then remove the plastic backing.

4. Continue to apply the foil until the entire surface is covered.

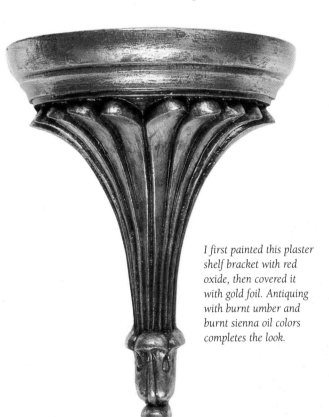

I first painted this plaster shelf bracket with red oxide, then covered it with gold foil. Antiquing with burnt umber and burnt sienna oil colors completes the look.

The trim on this board is gold foil that I antiqued with burnt umber oil color.

SPECIAL TECHNIQUES

I call the procedures in this chapter *special* techniques because they can all add wonderful dimension to your work and because they fall somewhere between the painted finishes described earlier and the decorative painting to be discussed later on. Including staining, stenciling, decoupage, and faux stucco among others, these techniques, while seemingly very basic, will set your work apart from that of others and give it a more professional look.

Staining Wood

MATERIALS

Glazes
Water-based glazes (any colors)

Brushes
Glaze application brush
Varnish application brush

Miscellaneous
Raw wood surface
#220 grit sandpaper
#400 grit sandpaper
Sanding block
Tack cloth
Lint-free cotton rags
Water-based polyurethane varnish
Artists' repositionable tape (optional)
Burnishing tool (optional)

The staining of raw wood can add a surface richness that nature didn't provide. Staining with bold, vivid colors can also make wood dramatic. The use of water-based glazes makes staining easy and attractive. By using some simple masking techniques, you can create special inlaid or marquetry designs. Don't be afraid to try staining in bright colors, like cranberry or forest green. The effects are stunning. Note that you should stick with the professionally manufactured water-based glazes for this technique; don't use a homemade glaze, made with the acrylic glazing medium, because it will streak and cause problems later on.

INSTRUCTIONS

1. Sand the raw (unprepared) wood surface until it is smooth. Begin with #220 grit sandpaper and then use #400 grit sandpaper to finish. The sanding block will expedite the process. Make sure the surface is free of any glue that may have been used in furniture construction—the glaze will not stain over glue.
2. Wipe the wood with a tack cloth to remove any sanding dust.
3. Apply the glaze straight from the container with a glaze application brush. (See photo 1.) Move immediately on to the next step.
4. Wipe the excess glaze from the surface using a soft cotton rag. (See photo 2.) If the glaze stain is too dark or difficult to remove, rub the surface with a damp rag.
5. If you want to apply stains of different colors to separate areas on the same piece, mask out the area to be a different color with artists' repositionable tape. Once you stain one section, remove the tape and let the stain dry. Apply tape over this area that you just stained, and carefully burnish the edges to prevent the next glaze color from seeping underneath to the previously stained area. Stain the remainder with a complementary or a contrasting color. (See photo 3.) Be careful when staining with more than one color—accidental glaze drips are virtually impossible to remove. I recommend that you begin staining with the lightest color and work toward darker colors. When you are finished staining, remove the tape carefully. (See photo 4.)
6. After you apply all your colors, let the glaze stains dry overnight, then varnish the piece using the varnish application brush. You can use either a matte- or gloss-finish water-based varnish. (See page 124 for varnishing instructions.)

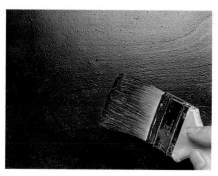

1. Apply the water-based glaze to the raw, sanded wood using a glaze application brush. I'm using a moss green color for this section of my wood.

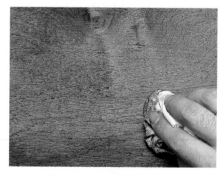

2. Wipe the excess glaze from the surface with a cotton rag.

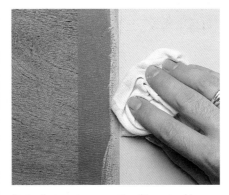

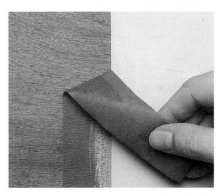

3. Apply tape to one section (I'm using blue tape here), and stain the adjoining section.

4. Carefully remove the tape.

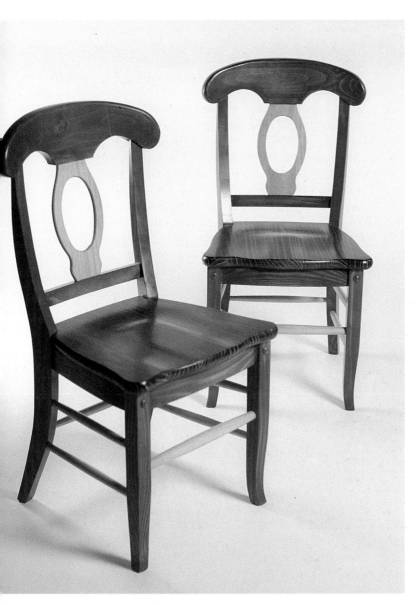

These country chairs have a fresh and funky look because of their brightly stained appearance. By using several different colors, I gave the chairs more character. Try staining in colors other than wood tones; the look is often exciting and unusual. In the detail below, you can really see the different colors.

Flyspecking

MATERIALS

Paints and Painting Mediums

Artists' tube acrylic or oil color (any color)

Mineral spirits (if you use oil colors)

Miscellaneous

Paint tray

Palette knife

Water

Toothbrush

Flyspecking is a technique that adds interest to many painted finishes. It is accomplished by loading a toothbrush with thinned paint or solvent and running your thumb over the bristles to spritz the surface. When you flyspeck with paint, you add color to the surface. When you flyspeck with solvent, you will repel color that is already on the surface and also allow the underlying surface to become visible in some spots. To cause the latter, repelled-paint reaction, flyspeck with mineral spirits over a water-based glaze, or do it with alcohol over thinned acrylic paint. When flyspecking with solvent, make sure that the surface paint is still damp, otherwise the paint will not react to the solvent and you won't achieve the desired repelled-paint effect.

As you've probably noticed, many of the procedures in this book refer to flyspecking. In this demonstration, I'll flyspeck with paint.

INSTRUCTIONS

1. In a paint tray and using a palette knife, mix the proper medium with your paint to dilute it to a thin, inklike consistency. To thin acrylic paint use water; for oils, use mineral spirits. Make sure the paint is not too thin, because if it is, large blobs of it will drip off the toothbrush onto the surface as you flyspeck.
2. Dip the end of the toothbrush into the thinned paint. (See photo 1.) Do not overload the toothbrush with color.
3. Point the bristles downward over the area where you want the specks to be. Gently pull your thumb or forefinger across the bristles. The specks will fall onto the surface. (See photo 2.) Always pull your thumb toward yourself. If you push your thumb or finger away from yourself, you will flyspeck yourself.

1. Dip the toothbrush into your diluted paint.

2. Drag your thumb or finger (toward yourself) across the bristles of the toothbrush, and let the paint specks fall on the surface.

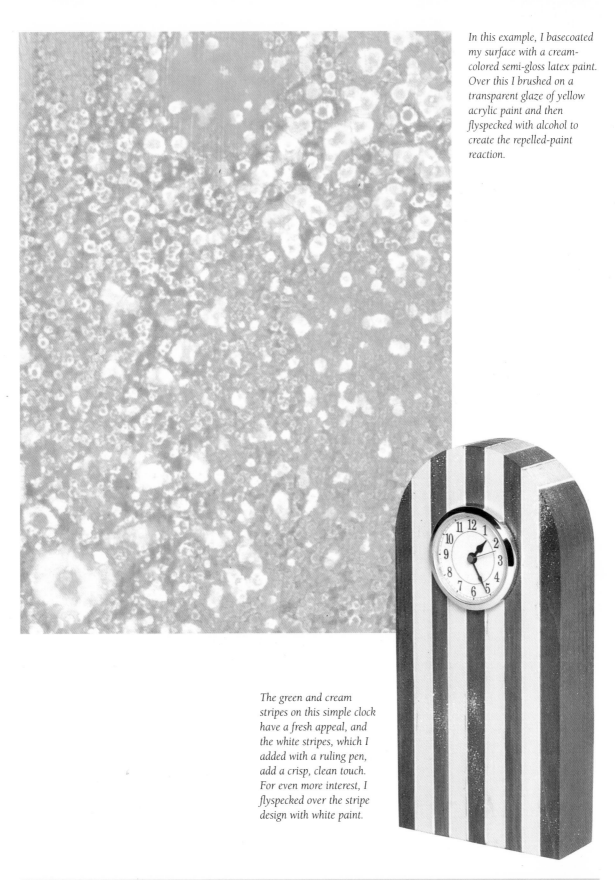

In this example, I basecoated my surface with a cream-colored semi-gloss latex paint. Over this I brushed on a transparent glaze of yellow acrylic paint and then flyspecked with alcohol to create the repelled-paint reaction.

The green and cream stripes on this simple clock have a fresh appeal, and the white stripes, which I added with a ruling pen, add a crisp, clean touch. For even more interest, I flyspecked over the stripe design with white paint.

Decoupage

MATERIALS

Decoupage Supplies
Curved-blade decoupage scissors
Straight-blade decoupage scissors
X-Acto knife with #11 blades
Decoupage glue
Decoupage cutouts

Brushes
Poly brush
Varnish application brush

Miscellaneous
Kitchen sponge
Water
Soft rubber brayer
Water-based polyurethane varnish

Decoupage is the art of decorating a surface by applying cutouts, which are usually paper, and then coating them with varnish. The technique originated in Italy, probably in the 17th century, and quickly spread across Europe. Decoupage fell out of fashion primarily because of the time needed to complete a project. Today, however, with the advent of marvelous, water-based, water clean-up products, decoupage is back in fashion. Using decoupage, you can easily create the illusion of a handpainted piece with minimal effort. You can use the technique to embellish accessories, like picture frames and boxes, or small pieces of furniture. Just make sure that you properly prepare your surface, or work over a previously applied paint finish.

So, you might ask, "What can I use for decoupage designs?" Decoupage prints are everywhere. You can use prints specifically manufactured for decoupage, available in craft stores; many of these prints are very easy to cut out, and some will even give the illusion that you painted the piece yourself. Or, you can use images that you cut out from greeting cards, pictures in magazines, giftwrap, or anything else you choose. One option that I use is to make color copies of a design I want to decoupage. By using this method, I can enlarge or reduce my designs and create multiples from a single original. In this technique, the only limitation is your imagination.

INSTRUCTIONS

1. Carefully cutting out your prints is the first step in creating a beautiful project. You can use either decoupage scissors (available in craft stores) or an X-Acto knife for this. Whichever tools you choose, the care that you take when cutting your prints will show in the finished project. The special, curved-blade decoupage scissors are ideal for cutting intricate or delicate prints that have a great deal of curved areas. Hold them with the curve facing away from the print. (See photo 1.) Make inside cuts first, then trim the outside of the print. When maneuvering around a curve, rotate the print into the blade of the scissors. Move the print, not the scissors. If you need to remove the inside area of a design, start a hole with an X-Acto knife, and then use the scissors to finish the cut.

 If you are using only an X-Acto knife, lay the print face up on a suitable cutting surface (pieces of glass, old mirrors, or self-healing cutting mats are good choices). Begin by gently pulling the knife along the design. Always place your free hand away from the blade to avoid cutting yourself. Use only the very tip of the blade, and replace the blades frequently; you will get better cuts and have more control with a sharp blade. With some practice, you will acquire skill at turning corners with the knife; be patient.

2. After you cut out your designs, you are ready to glue them to the surface. You need to use specially formulated decoupage glue, which has a very thin consistency and is available in craft stores. Apply a thin coat of glue to the back side of the print using the poly brush. Be sure you completely cover the back of your print with glue, paying special attention to the edges of the print. (See photo 2.) Turn the print over, and place it where you want it on the surface. If you are applying more than one print to the surface, in a layered, collage fashion, begin with the prints that are to be the back or underlying layers and work forward, or upward, to the top layers.

3. Begin to smooth out the print with a damp kitchen sponge, working from the center of the design out to the edges. (See photo 3.) If you are working with a few layers of prints, you should smooth out each layer as you apply it. You want to remove any air pockets that may be behind the print and make sure that all edges are well adhered to the surface. A soft rubber brayer also works well for this.
4. Repeat this procedure for all prints that you wish to apply to the surface. Wipe any excess glue away with a damp sponge. Allow the project to dry *overnight*. If you rush the process and do not allow for overnight drying, your prints might wrinkle severely.
5. Apply several coats of water-based polyurethane varnish to the surface with a varnish application brush.

1. Carefully trim the decoupage print using curved decoupage scissors (or an X-Acto knife).

2. Apply glue to the back of the print with a poly brush.

3. Use a damp kitchen sponge to press out any air pockets from behind the print and smooth it out.

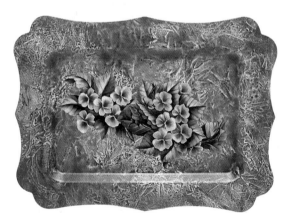

I painted this Chippendale-style tray in white and glazed it with a moss green water-based glaze. I manipulated the glaze with alligator-style texturizing and applied the decoupage violet design over this once the glaze was dry.

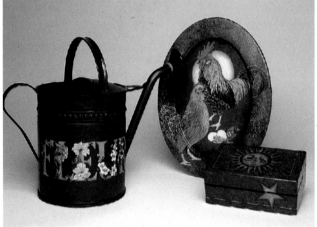

These three pieces were all decorated with decoupage designs that were placed over painted finishes. The metal watering can makes a beautiful decorative accessory with its design of "fleurs" spelled out in beautiful, floral decoupage letters. The oval platter was antiqued in the center panel and flyspecked on the edge; the chicken, rooster, chick, and eggs are all decoupage designs. The small box is adorned with both celestial decoupage prints and flyspecking, and a ruling-pen stripe in metallic gold completes piece.

Stenciling

MATERIALS

Stencil of your choice

Artists' white repositionable tape

Paint trays

Artists' tube acrylics (any colors)

Stencil brushes (a small, medium, and large should fit most needs)

Paper towels

Flat or semi-gloss latex paint

Stenciling is a very old technique that has experienced swings in popularity over the years. A few years ago, stenciling was thought appropriate only for use in interiors with country-style decorating themes, but now stenciling is used in a variety of design schemes. There are many precut stencils (available in craft and some art supply stores) for you to choose from today; some are very simple while others are quite complex. Regardless of how intricate the stencil is, the technique of applying color remains the same. To complete the stenciling, I prefer acrylic paints, but you can use oil-paint sticks (which basically are oil paints in stick form but with a few compositional differences), or cream stencil paints (available in craft stores).

With the wide range of stencils available today, you can use them to embellish an accessory or piece of furniture, or to add a border to, or create an overall pattern on, a wall. You can also apply them over previously executed paint finishes. Never limit your ideas; if you can imagine it, you can create it. And, don't forget that you can combine different stencils to make your own special look.

INSTRUCTIONS

1. Position the stencil on the surface where you want your design. Use the white repositionable tape to secure it in place. Note that in this demonstration, I first basecoated my surface with blue flat latex paint. (See photo 1.) Of course, if you are stenciling over some other paint finish, you won't be doing this.

2. Put some of each acrylic color on a paint tray. Pick up a small amount of the paint on the tip of a *dry* stencil brush. You cannot stencil with a damp or wet brush because the moisture will cause the paint to bleed beneath the stencil. Swirl the brush on a paper towel, which you have folded in quarters, to disperse the paint in the brush and also to remove any excess color. (See photo 2.) You don't want to have a lot of paint in the brush because it will bleed under the stencil. If you are using multiple colors, you should have a separate brush for each hue. This will save you having to wash the brush frequently and wait for it to dry.

3. Begin stenciling by placing the brush at the outside edge of the stencil element. Apply the paint in a circular motion.. This is a standard stenciling brushing technique that will prevent you from pushing paint under the stencil. (See photo 3.) Concentrate the color at the edge of the stencil (this looks best). If you want to shade or highlight the stencil shape at its edges, do so at this point before you move the stencil.

4. Move the stencil to the next area where you want to place an element. Secure the stencil in place with the tape, and repeat steps 2 and 3 until your overall design is complete. (See photo 4.)

1. Basecoat the surface with your chosen latex-paint color.

2. Dip your stencil brush into the acrylic paint, and remove the excess by swirling the brush on a paper towel.

3. Apply the paint in a circular motion to the edges of the stencil shape.

4. Shade or highlight the center of each stencil element.

I first stained this star-studded frame with dark blue water-based glaze. I applied the stars with two tones of metallic gold and treated the edges of the frame with gold foil.

In this detail of the star frame, you can clearly see both the staining and the stenciling.

Striping Walls

MATERIALS

Paints
Semi-gloss latex paint (any colors)

Brushes
Glaze application brush
Basecoat bristle brush

Miscellaneous
Ruler or yardstick
Pencil
Carpenter's level
Chalk
Painters' mask-out tape or artists' repositionable tape
Burnishing tool

The effect achieved by painting stripes on a wall may seem a bit strange, but it is an exciting and customized look that is very easy to create. Many times, you cannot find striped wallpaper in just the right colors, or the stripes are not the right width. By painting the stripes yourself, you can get just the look you want. Another interesting aspect of creating your own stripes is that you can execute a painted finish within the stripes—something no wallpaper can match. Ragging and texturizing are two techniques that work well within the stripes.

Careful planning helps in this technique. By predetermining which stripes are to be painted or finished, you can ensure that you won't have to paint into corners or around odd sections of the wall.

INSTRUCTIONS

1. Prepare the wall according to the instructions on page 27, and basecoat it using semi-gloss latex paint (and a roller paint applicator). Allow the paint to cure (dry) thoroughly before proceeding.
2. Measure the width you want the stripes to be and mark these spots on the wall with a pencil. (See photo 1.) Note that you only have to make small marks for this.
3. Use the carpenter's level to draw the stripe guidelines so that you are sure the stripes are truly vertical. Place the level against your pencil mark, align it until the bubble indicates that you are holding it vertically (the bubble should be in the center of the two lines), then draw a pencil line. (See photo 2.) Move the level up or down the wall, aligning it each time, and continue the line from ceiling to floor. Repeat for each stripe. Take your time, measure carefully, and hold the level steady as you mark the stripes. There is nothing more disheartening than to mark a whole wall only to find that you have mismeasured or misaligned one stripe. Even if only one line is not vertical, the whole effect will be ruined.
4. Using a piece of chalk, make a mark on alternate stripes to indicate which stripes will be painted.
5. Using the painters' tape, mask out the stripes that you aren't going to paint. Apply the tape carefully along your pencil lines. (See photo 3.) Once you apply a strip of tape to a stripe, take a moment to burnish it in place with the burnishing tool so that the paint doesn't seep underneath it.
6. Paint the unmasked stripes (one at a time) with a color, or execute a painted finish in them. (See photo 4.) For a painted finish, use a glaze application brush; for a solid color, use a basecoat bristle brush. If you need to, you can "fudge" some of the stripes; adding half an inch to extend a stripe into a corner will not be noticeable, and it can make the whole painting job much easier. Allow the paint to dry.
7. Carefully remove the tape. (See photo 5.)

TIP

You can create a stunning effect by using the same paint color, but in different sheens, for both the stripes and the wall. For example, you can paint the wall with the gloss finish and the overlying stripes in the flat finish. The effect is subtle but beautiful.

1. Measure the width of the stripes, and mark the wall with a pencil.

2. Hold the carpenter's level against your pencil marks. Make sure the level is vertical, and then mark the edge of the stripe.

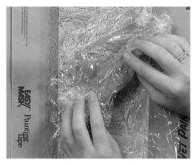

3. Apply tape along the edges of the stripes to cover the areas that you aren't painting.

4. Execute the paint finish within the uncovered stripes. (I'm texturizing here over semi-gloss latex paint.)

5. Remove the tape from the wall.

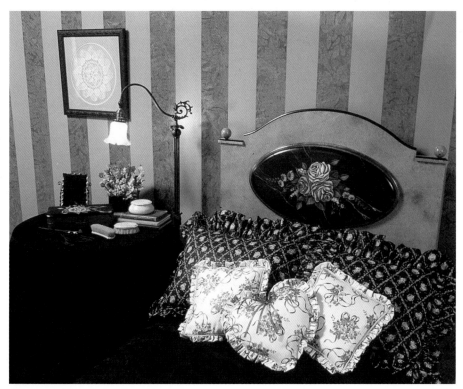

This bedroom features both painted furniture and walls. The headboard is ragged and flyspecked, the oval on it is gilded and antiqued, and the background behind the painting is marbleized. The painted stripes on the walls have alligator-style texturizing in them. The look is unique and easy to achieve.

Lining

MATERIALS

Paints

Artists' tube acrylic (any colors)

Brushes

#5 synthetic-bristle round brush

Flat brush

Miscellaneous

Paint tray

Palette knife

Water

Pencil

Cork-backed or raised-edge ruler

Ruling pen

Paper towels

Scrap paper

Adding a pinstripe or decorative line to a piece adds a special touch and makes a painted item look more finished. You can use linework to add interest or to repeat colors. You create the lines themselves with a draftsman's tool, called a ruling pen. The ruling pen looks like tweezers with a turn screw on one side. You adjust the width of the line by turning the screw to open or close the end of the pen. You can fill the pen with thinned oil, acrylic, or latex paint, and you can also use water-based glazes in it. I'm using thinned acrylics in this demonstration. The pen is available at art supply stores that carry drafting tools. Becoming proficient with the ruling pen takes some practice, but the effort you put forth will be rewarded many times over.

INSTRUCTIONS

1. In a paint tray and using the palette knife for blending, mix the acrylic paint with water until it is a thin, creamy consistency. This is the most critical aspect of this technique. Have patience as you work to get the paint just right. Make sure to mix this thoroughly to remove any lumps of paint. (See photo 1.)
2. Using a pencil, mark the line on the surface. Be sure to indicate start and stop marks. Position the raised-edge ruler along this line when you are ready to draw your paint line. Note that your straightedge must be raised off the surface so that paint does not collect and bleed under it. If you need to raise an edge off of a surface, taping pennies to the back of it is an excellent way to handle the situation.
3. Fill the ruling pen with the thinned acrylic paint. To correctly load the pen, pick up the diluted paint on the #5 round brush. Hold the pen so that the slot (opening) is facing up, and carefully rake the brush over the slot. The paint will collect in the slot. (See photo 2.) If the paint is the right consistency, it will hold in the pen and not drip out. Carefully wipe any paint off the outside of the pen with a paper towel.
4. *Test the pen on some scrap paper before you start on the surface.* You should hold the pen at a 45° angle to the paper, with the straight side of the pen against a ruler. If the paint is too thin it will "blob" when you touch the pen to the paper. If it is too thick, it won't flow out of the pen. Slowly drag the pen across the paper. If you can form a nice uniform line, you are ready to move to your real surface.
5. Fill the pen again, make a quick test line on the scrap paper (about 2" should give a good indication of how the paint is flowing), and then move to your surface and make the line against your straightedge. (See photo 3.) If a glob forms as you start or stop a line, use a clean flat brush and water to remove the unwanted section of the line. If you are making long lines, you can move the ruler and continue painting the same line. If you need to refill the pen to finish the line, simply start back about 2" on the finished line (so that your paint overlaps) and continue as before. (See photo 4 for the finished line.)
6. Repeat steps 2 through 5 to make all the lines on the surface. Once you complete all the lines and let them dry, erase any pencil marks.

When working on parallel sets of lines, start with the innermost lines and work to the outside edge.

If you want to make curved lines, you can use a Hogarth curve (French curve) or any curved object, such as a plate or a glass.

1. Thin the paint to the proper consistency in a paint tray.

2. Use a round brush to fill the pen with paint.

3. Hold the pen at a 45° angle as you drag it along the ruler to form your line.

4. The finished line.

This clock has very simple and severe lines. To add a refined element to the piece, I applied stripes. The stripes, done in metallic gold, also add a curved element. Use a protractor, Hogarth (French) curve, or some other circular instrument to make curved lines on a surface. After applying the lining, I antiqued the clock lightly with black acrylic paint.

This detail of the chest on page 41 shows blue alligator-style texturizing that has been embellished with lining. To create a border like this, measure carefully and apply the inner lines first, then the outer ones.

Faux Stucco

MATERIALS

Paints
Beige semi-gloss latex paint

Burnt sienna artists' tube acrylic

Burnt umber artists' tube acrylic

Glazes
Butter cream water-based glaze

Brushes
Basecoat bristle brush

Glaze application brush

Miscellaneous
Drywall joint compound (drywall mud)

Trowel

Palette knife

Paint trays

Water

Cotton rags

A faux-stucco finish will add textural interest to any surface to which it is applied. It is best suited for walls and accessory pieces that will not receive a great deal of handling, otherwise you run the risk of chipping the finish. For example, you could use it on boxes, frames, and obelisks or other decorative objects. (Metal is the best accessory surface material.) The degree of texture that the finish has depends on your personal taste. Some people want very little texture, while others like a great deal of it. The color drips that are a part of the technique give the appearance of water marks, and you can make these as subtle or bold as you choose. Use other colors (besides the ones I have chosen here) to achieve different looks on top of the drywall compound. Above all, have fun with this technique. It can really make your room a standout.

INSTRUCTIONS

1. Prepare the surface for painting. Begin applying the drywall mud (available at home improvement stores) with a trowel. (See photo 1.) Try to cover the entire surface and have texture in the mud. You might also find it useful to manipulate the mud with a palette knife to control and create the texture. The drywall layer should be about ⅛" thick; follow the instructions on the container. Allow the mud to dry completely; it will be a gray color when wet and white when dry. Do not rush the drying process. You will have bad end results if you try to work over the drywall mud while it is still damp.

2. Once it is dry, basecoat the drywall mud with the semi-gloss latex paint using the basecoat bristle brush. (See photo 2.) When the first coat is dry, apply a second one. Be sure to coat any crevices or texture with this basecoat; the drywall mud is very porous, and if the basecoat is not sufficient, it will quickly soak up any of the subsequent acrylic paint that you apply, as well as the glaze that you use to tone the overall effect. Allow this to dry completely.

3. In separate paint trays and using the palette knife for mixing, dilute the acrylic paints (here, burnt sienna and burnt umber) with water until they are both a very thin, flowing consistency.

4. Pick up your first color (here, burnt sienna) with the glaze application brush, making sure the bristles are fully loaded. Apply the paint along the uppermost part of the surface, and let the color run down the length of it. (See photo 3.) If the paint needs coaxing to run, dip your brush in water and dab it along the top area where you first applied the color. The paint should now flow down the surface. When applying the paint runs to the walls, make the color slightly stronger than you would like it to be when you are finished; the overglazing will tone it down quite a bit. If using a second color, move on to the next step before the paint dries; otherwise, let this application dry and go to step 6.

5. If you are using a second color, repeat step 4 with it. I'm using burnt umber here. Allow all the paint colors to dry.

6. With a basecoat bristle brush, apply the water-based glaze to the surface in a random manner. (See photo 4.) You should work rapidly when you apply this overglaze because it will set up quickly. If you find that the glaze dries too quickly for you, you might want to apply it with a damp rag, rather than a brush. In this way, you can apply it and scrub it around at the same time.

7. While the glaze is still wet, wipe the excess from the surface with a cotton rag, but let the glaze collect in the crevices of the drywall. (See photo 5.)

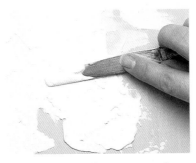

1. Apply the drywall joint compound to the surface with a trowel.

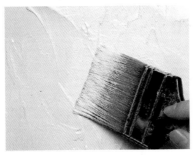

2. Basecoat the surface with semi-gloss latex paint using a basecoat bristle brush.

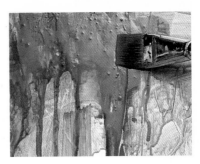

3. With the glaze application brush, apply runs of your thinned acrylic paint colors. I'm using burnt sienna and burnt umber.

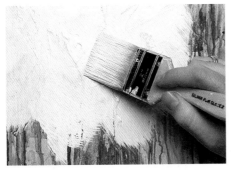

4. Apply the glaze with a basecoat bristle brush.

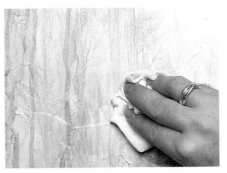

5. Use a soft cotton rag to remove the wet glaze from the surface.

TIP
You can use the rag to apply more glaze in any areas where you want to reduce the strength of the runs or highlight the texture of the stucco.

I decorated this mirror frame with the faux-stucco finish, giving it a rustic, stonelike appearance. In the close-up below, you can really see the depth of the faux stucco.

You can complete the faux-stucco finish in a variety of different colors. I painted this example with a pink color and then rubbed a sienna-colored overglaze into the texture, giving it a claylike look.

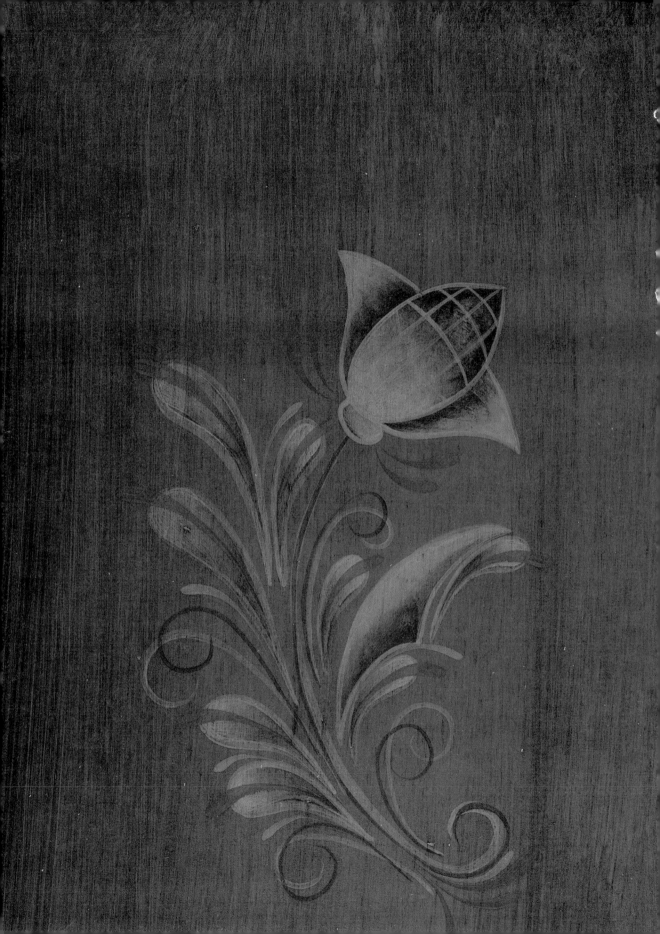

DECORATIVE PAINTING

Decorative painting is a fun technique that can add a unique touch to many surfaces; furniture and accessories are perfect for this type of embellishment. The aesthetic possibilities are endless here because you can create any design you like; if you can imagine it, you can paint it. Don't be discouraged if you have little or no painting experience—as long as you have the desire to learn, you will improve and paint beautifully.

The Drybrush Technique

MATERIALS

Artists' Tube Acrylics

Cadmium red medium
Alizarin crimson
Hooker's green
Cadmium red light
Cadmium orange
Cadmium yellow light
Titanium white
Ultramarine blue
Burnt umber
Black

Brushes

Flat brushes in a variety of sizes
Liner brush

Miscellaneous

Chalk
Wax-coated palette paper
Water
Paper towels
Palette knife

Decorative painting can be done in oils or acrylics, and each medium has a distinctive look. Your choice of medium depends only on personal preference. I work primarily in acrylics because I enjoy the rapid drying time and the look that I can achieve in this medium. In this chapter, I will demonstrate painting using the drybrush technique. I created all of the decorative painting examples in this book using this technique, but it is only one method. There are many other approaches to decorative painting, and there are countless books which describe decorative painting techniques in detail. My objective here is to give you a starting point for decorative design work to be used in conjunction with painted finishes. Note that I've listed the skill level as "moderate," but this will vary somewhat with the complexity of your designs.

It would be impossible to provide complete, explicit instructions for all the painted subject matter shown in this book, however the technique can be taught, and I painted all the subjects using the same basic approach. It doesn't matter whether you are painting an apple, a brushstroke design, or a rose. The only difference is in the use of color. I use the colors listed at left quite frequently, and I also often use burnt sienna, dioxazine purple, raw sienna, and yellow ochre or yellow oxide.

INSTRUCTIONS

1. Draw your design elements on the surface in chalk. You can use the design patterns that I provide on page 126, and follow the shading guidelines indicated on them. Also, put a bit of each acrylic paint color on a piece of wax-coated palette paper. (You'll find this at most art supply stores.)

2. Using the largest flat brush that you can comfortably fit into the area, basecoat each design element in its designated acrylic color. (See photo 1.) You should use brushes with a blend of natural and synthetic bristles for this technique, and they should be dry for this step. Always try to use the largest brush that you can work with because it is faster this way. The basecoat should have neat smooth edges, but if there are ridges in the rest of it, that is great. Pat or stipple (dab up and down on the surface) the brush to get a bit more texture in the basecoat. The texture will not show up until you begin highlighting, so be patient. If the basecoat isn't opaque, you will have to apply a second coat, and this is another opportunity to create a little more texture. Once all the elements are basecoated and opaque, allow them to dry thoroughly.

3. Once the basecoat is dry, you can begin to apply shading to the elements. This is the *only* step that requires moisture in the brush. Shading is accomplished by means of floated, or graduated, color. To do this, you must correctly load your brush with paint. First, dip a flat brush in water, and blot the excess on a paper towel. Pick up your shading color on a corner of the bristles; it should be several values darker than the basecoat color. Blend this color in the same place on your palette paper until you have a smooth gradation of color across the brush bristles, from dark paint on one side to clean water on the other. It is important that the color fade off before it reaches across the brush, or you will end up with an unsightly, harsh line of color where the shading stops on your design. You want the shading to gently trail away with no indication of its ending point. Apply this paint to your design. (See photo 2.) Let it dry completely. If it is not totally dry, chances are you will lift off the basecoat when you begin applying the highlights in the next step.

4. Now you are ready to develop the highlights. Highlights are developed slowly, through multiple layers of closely related colors. Each layer of color occupies slightly *less* space, and is *one* value lighter, than the preceding layer. It is important that each highlight be smaller than the one before it so that you can see a bit of each color and value. I mix my highlight colors with a brush so that I can lighten them carefully one value at a time. You should build the values in the highlights gradually; never skip over (or omit) any values or the look will be spotty and distracting. Also, once you begin highlighting, always keep a bit of the last color you used on your brush for color continuity.

Begin by picking up a color that is slightly lighter than the basecoat color. (Use a dry brush here.) This will be your first highlight color. Wipe the brush on a paper towel to remove the excess paint. You need only a scant amount of paint on your brush; if you pick up too much, you will not be able to brush the surface without putting globs of paint on it. You want to skim the brush across the surface and deposit color only on the tops of the ridges and textures in the basecoat. Begin brushing the color on. Do not use any specific motion, just brush the color on randomly, as if you were using a pencil eraser. (See photo 3.) Do not clean your brush in water as you work. Remember, this is called dry brushing. If necessary, dry-wipe the brush on a paper towel, and continue highlighting.

5. When you are ready, switch to the next lighter color and value. Always begin highlighting in the area where you want the final highlight to be the strongest. If you continually start in the same spot, your light area will be in the correct place when you are done, and the form will be correctly rendered. So, regardless of where you are in the highlighting process, always begin in the same spot. Make sure that you can see all the colors you apply, so that they will all blend optically. Continue highlighting this way, adding all your colors and values. (See photo 4.)

6. Add any detail work with a liner brush and thin, flowing paint. (A liner brush is a small, thin round brush.) Add any tints using a transparent wash of color on a flat brush. Tints help to create further color harmony in the design and are always applied at the end of the decorative painting process so that you can best determine where on the image they should be placed.

1. Basecoat your design with the appropriate color. For my apple, I am using cadmium red medium. Use a flat brush, and pat the paint onto the surface to create some texture in the basecoat. Let this dry. If necessary, apply a second coat to be sure that the basecoat is completely opaque.

2. Start shading the design with your darkest color. I'm using a wide flat brush, which I side-load with a mixture of alizarin crimson and Hooker's green on one half of the bristles and water on the other half. You might need to apply some of your shading more than once in order to make it dark enough. Allow this to dry before moving on.

3. Begin applying the highlight values to the design. Use a scant amount of color on your brush. I start with my basecoat color, cadmium red medium. Next, I use a mixture of cadmium red medium and cadmium red light. Then, I add more cadmium red light to that color and apply some of the resulting lighter hue. Finally, I add the lightest highlight of pure cadmium red light.

4. If necessary, continue adding highlights to the design. Here, I'm adding highlights of a mixture of cadmium red light and cadmium orange. I also use some highlights of cadmium orange alone. I then highlight with mixtures of cadmium orange and cadmium yellow light, and cadmium yellow light and titanium white. I finally add some pure white highlights. The light blue detail on the left side of the apple is a mix of titanium white, ultramarine blue, and burnt umber. The stem is burnt umber highlighted with titanium white, and the shadow is burnt umber and black.

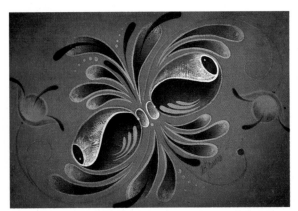

I derived this painted decoration from a Pennsylvania Dutch style design. I drybrushed the design in bright colors and then antiqued it to soften the hues.

I painted this book box with another Pennsylvania Dutch style design. I first foil-leafed the edges, or "pages," of the book and then antiqued them with burnt umber. I left streaks in the antiquing to give the illusion of pages.

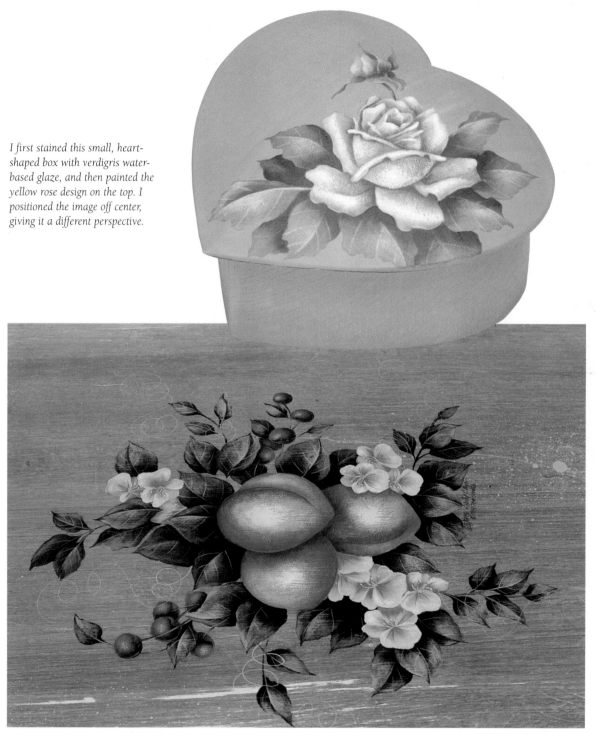

I first stained this small, heart-shaped box with verdigris water-based glaze, and then painted the yellow rose design on the top. I positioned the image off center, giving it a different perspective.

I drybrushed this design of peaches and cherries on top of a rubbed finish.

ANTIQUING

Antiquing is one of the most versatile paint finish techniques that you can use. It can add an extra touch of professionalism to just about anything, and can be used both on its own as a finish or in combination with other techniques. With it you can create an aged look that would otherwise take years to acquire. You can antique with either oil-based or water-based products and in either transparent or opaque styles. The looks are slightly different, but both are effective. The easiest process, and the one that allows the most working time, is oil-based antiquing; this is because oil-based products take longer to dry than water-based ones.

By using earth-tone colors in your glaze mixtures, you can achieve a subtle antiqued look. If you leave heavy antiquing in areas, your piece will look very old. By using intense, bright colors, you can highlight the surface dimension on textured objects. Regardless of which antiquing methods you choose, you will enjoy the mellow look that antiquing gives a piece.

Transparent Antiquing

MATERIALS

Paints
Seafoam green semi-gloss latex paint

Sap green artists' tube oil colors

Ivory black artists' tube oil colors

Glazing Mediums
Clear, oil-based glazing medium

Brushes
Basecoat bristle brush

Varnish application brush

Glaze application brush

Soft blending brush

Miscellaneous
Water-based polyurethane varnish

Paint trays

Palette knife

Paper towels

Cotton rags

Transparent antiquing can add mellow charm to many pieces. It is especially well suited for use on wooden furniture and accessories. You can use the technique to tone down bright colors or to emphasize any carved surface ornamentation or relief designs where the antiquing will collect in the crevices (see the green planter on page 120). Earth tones are the most common colors for this finish, but you can choose others. Be brave, and experiment with other hues. I like to use two-toned antiquing, in which I paint an object with a light color and apply antiquing in a darker value of that same color. The results can be quite dramatic.

OIL-BASED METHOD

The use of oil colors in antiquing gives you a richness that cannot be duplicated with any other medium. The oil-based products allow you the greatest control over the antiquing process and the longest working time before they dry. You have the choice to leave the surface heavy with antiquing or to remove a great deal of it, leaving only a mellow sheen behind.

I urge you to experiment with your antiquing. Try very heavy antiquing on some pieces and light, delicate antiquing on others. You will soon learn what suits your personal tastes best. Who knows, you may even surprise yourself with the results of your experimentations. (For this demonstration, I'm using green hues.)

INSTRUCTIONS

1. Basecoat the surface with whichever color semi-gloss latex paint you've chosen, using a basecoat bristle brush. (See photo 1.) If necessary, apply a second coat to ensure an even, opaque surface. Let this dry. If you are antiquing on a piece that is already painted, skip this step and start with step 2.

2. Seal the surface by applying a coat of water-based polyurethane varnish with a varnish application brush. Allow the varnish to dry thoroughly. Note: Whether you are using these techniques over a previously applied painted design or finish, or are simply antiquing a basecoat, be sure to seal the surface with a coat of varnish before applying any antiquing. If you don't, the antiquing may stain the piece. Also, if there is an accident, you will have to scrub very hard to remove the antiquing solution, and you might damage the underlying painting or finish.

3. Tint the clear, oil-based glazing medium with artists' tube oil colors as follows. If you are using the same colors as I am, first mix three parts of sap green paint to one part ivory black in a paint tray. Place this mixture in a clean tray and add enough of the glazing medium to make the paint soupy. A 1:4 ratio of paint to glazing medium is a good one. Be sure to mix the color in thoroughly with the palette knife so that there are no lumps in the glaze.

4. With a glaze application brush, apply the glaze to the surface. (See photo 2.) If the surface is dimensional, be sure to work the glaze into all the crevices. Move on to the next step before the glaze dries.

5. With a paper towel or a soft cotton rag, wipe the glaze from the surface in the area you want to be highlighted (or lightened). This is typically the center area. Rub in a circular motion. (See photo 3.) As you move outward from the initial starting point, use less pressure. This will result in a soft gradation in color value from light to dark. Change your rag frequently as you wipe the excess glaze from the surface, and always start wiping in the same original spot to help achieve the nice value gradation.

6. Once you remove all the glaze you want, you can refine the blending by lightly dusting the surface with a dry soft blending brush as if you were using a feather duster. Hold the brush perpendicular to the surface and use it in a sweeping manner. (See photo 4.) Use a very light touch. You should not be removing glaze with this brush but, rather, softening and removing any stray rag marks.

ACRYLIC OR WATER-BASED METHOD

The steps for acrylic antiquing are the same as those for the oil-based method, with the only notable exceptions being that you must apply a liberal coat of *water-based* glaze to your surface and you must work very rapidly to remove the glaze. This is because water-based glazes set up much, much faster than oil-based ones. All the materials are the same as with the oil-based technique except that you should be using *acrylic* tube colors and clear, *acrylic* glazing medium. You can also use the premade water-based glazes instead of mixing your own.

1. Apply the semi-gloss latex basecoat to the surface using a basecoat bristle brush.

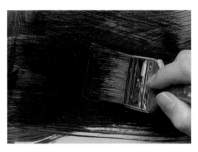

2. Apply the glaze using the glaze application brush.

3. Use a soft rag to remove the excess glaze from the surface.

4. Refine the antiquing with a soft blending brush.

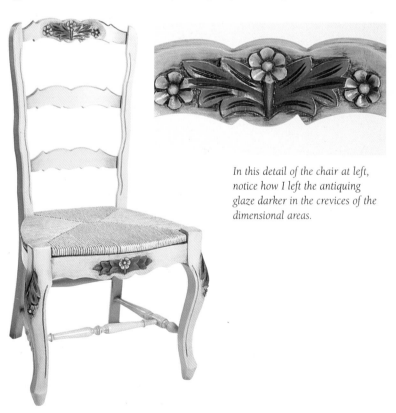

This charming carved chair seemed to immediately call out for some simple painting and antiquing to highlight its design. I first basecoated the chair with a light cream-colored semi-gloss latex paint and painted the carved details in a very simple manner. Then, I antiqued the entire chair with an oil-based glaze made from asphaltum and burnt umber colors.

In this detail of the chair at left, notice how I left the antiquing glaze darker in the crevices of the dimensional areas.

Opaque Antiquing

MATERIALS

Paints
Black semi-gloss latex paint
Red semi-gloss latex paint

Brushes
Basecoat bristle brush
Varnish application brush
Glaze application brush

Miscellaneous
Water-based polyurethane gloss varnish
Paint tray
Dishwashing liquid
Water
Palette knife
0000 steel wool
3M scrubby pad
Clear acrylic spray
Cotton rags

This type of antiquing is a bit more primitive in appearance than the transparent style and is one of my favorite methods. In some ways it reminds me of a project I did in first grade in which I colored a design with crayons and then painted over it with black tempera paint. My design remained visible and intact because the waxy crayons repelled the paint, preventing it from covering the image. The difference here is that you must scrub a little to reveal the design, but the results are just as exciting. Be aware that this process requires a bit of time because the varnish that you use must dry overnight.

Opaque antiquing looks best over rich, dark colors, but with some experimentation you can come up with some light variations of your own, as well. Note that you should only use acrylic or water-based products for this technique because oil-based ones would take days to dry. For this demonstration, I'm using a rich red with black antiquing.

INSTRUCTIONS

1. Using the basecoat bristle brush, basecoat the surface with the semi-gloss latex paint that is to be your bottom color. (See photo 1.) If the first coat doesn't cover completely, let it dry and apply a second one. Let the second coat dry, too.

2. Complete any decorative work (painted designs or other finishes) that you wish to put on the surface, and allow it to dry.

3. Apply five or six coats of water-based polyurethane gloss varnish with a varnish application brush, letting each coat dry between applications. (See photo 2.) Allow the final coat to dry overnight before proceeding. You must apply several coats of varnish to the surface otherwise you will scratch through to the underlying paint or designs when you remove the antiquing mixture.

4. Pour 3/4 cup of the semi-gloss latex paint that is to be your antiquing color into a clean paint tray. To this add approximately 1 tablespoon of dishwashing liquid and 2 tablespoons of water. Mix these ingredients together with the palette knife. This is your antiquing mixture. Note that these amounts are approximate. You will need to test your mixture to be sure that the antiquing will scrub off the surface. If the antiquing is stubborn, add a bit more dishwashing liquid to the solution. Please make sure you do this test before working on your actual surface. There is nothing sadder than having a lovely piece ruined by antiquing that will not come off the surface. Use a scrap surface of the same material, or an area of the actual surface that won't show.

5. Brush the antiquing mixture onto the surface in a random manner with the glaze application brush. (See photo 3.) Do not apply a heavy coat, just enough to cover the surface. Let this dry. Note that the antiquing mixture will lose its shine as it dries.

6. Using the 0000 steel wool pad, rub the surface in a circular motion to remove the antiquing. You might find that you need to use a coarser 3M scrubby pad for this. (See photo 4.) Your local grocery store should have 3M pads. If the antiquing is difficult to remove, wipe the surface with a damp rag and then immediately scrub it with the pad. The moisture will help soften the antiquing, making it easier to remove. If the surface is damp from the rag, let it dry before going to the next step.

7. The surface is fragile at this stage. Before applying any type of varnish, spray the surface with a clear acrylic spray to seal it, and let it dry.

1. Apply the semi-gloss latex basecoat with a basecoat bristle brush.

2. Apply several coats of water-based polyurethane gloss varnish with a varnish application brush.

TIP
I like to make ridges in the basecoat by applying the paint in a sloppy, rather than smooth, manner. This texture adds an attractive quality to the finish because it tends to hold some of the antiquing.

3. Brush on the antiquing mixture with a glaze application brush.

4. Remove the antiquing with steel wool or a 3M scrubby pad.

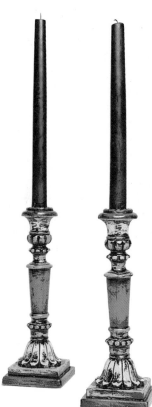

These plaster candlesticks were polychromed (painted in many colors) with a rainbow of high-chroma colors (high-chroma or high-intensity colors are those which are very bright or strong and highly pigmented). The black antiquing softens and unifies the coloration.

In this detail of the candlestick base you can see how the antiquing settles into the crevices of the surface.

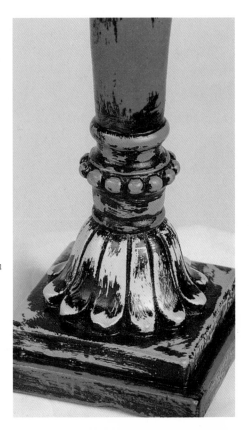

I painted the design on this planter using bright colors. The antiquing process mellowed and softened the overall effect and also gave the painting a highlighted look.

This detail of the flower pot at left clearly shows how the antiquing settles into the ceramic relief.

This terra-cotta flower pot has interesting relief designs that made it a prime candidate for antiquing. The antiquing catches in the grooves and emphasizes the design.

The fruit design on this cocktail table was inspired by the work of the late American decorative painter Robert Berger. I basecoated the surface in a casual manner, leaving many of the brush marks visible. After the basecoat was dry, I added the decorative painting and antiqued the entire surface in the opaque method. I then flyspecked heavily with black.

Here you can see the details in one of the fruit designs on the top of the table. This arrangement is composed of some pears, apples, grapes, strawberries, peaches, and a watermelon, and the pattern for it appears on page 130. I applied the antiquing over the painted details to tone them down and give the overall piece an aged look.

This is a close-up of the other fruit design from the tabletop; this one has pears, apples, grapes, strawberries, peaches, and half a cantaloupe. You can find my pattern guide for it on page 131.

This is a detail of the flower design that I used in the corners of the tabletop. The pattern for it is on page 129.

Here you can see the antiquing and lining details on the sides of the table.

VARNISHING

Up until this point, we've concentrated on the care that must be taken in the application of painted finishes to interior surfaces and objects. You must also take care, however, to protect your finishes and decorative paintings once they are complete. The techniques described here will teach you how to successfully protect your work so that it can withstand the effects of use and time.

Applying Brush-On Varnish

MATERIALS

Varnishes
Water-based varnish

Brushes
Varnish application brush

Miscellaneous
Tack cloth
Wooden paint stirrer
#400 grit sandpaper
Water
Ivory bar soap
Cotton rags

Most painted finishes that are applied to wall surfaces do not need a protective coat of varnish. This is because the oil-based glaze used has varnish naturally as a part of its make-up, and this helps serve as a seal and barrier. The water-based glazes, too, are formulated for use in interior spaces and do not require the use of a varnish when applied to walls. If you think about it, most of the wall paint currently used in your house is not varnished. The only exception to varnishing a wall could be the use of painted finishes in a bathroom or kitchen. Both of these areas are exposed to a little more use and abuse than the rest of the house.

Furniture, accessory pieces, and floorcloths should receive several (at least three) coats of varnish to protect them because they undergo a greater amount of everyday handling and traffic. Whether you are varnishing walls, furniture, or small objects, you should always use a *brush-on* varnish. Spray-on varieties are not used for final varnish coatings.

There are many types of varnishes, the most traditional being the oil-based and polyurethane kinds. They are both fairly slow-drying, with the former requiring 12–24 hours and the latter needing 4–5 hours. The polyurethane varnishes come in a variety of sheens and have a tendency to darken and yellow over time. Newer on the varnishing scene are acrylic varnishes, which are water-based, often low-odor, and fast-drying (roughly 1–1½ hours). They won't yellow, but they are often not available in as many sheens as the polyurethane kind. I'm using water-based here.

Varnishing is a two-part process comprised of the actual varnishing and also a wet-sanding procedure. After applying three or more coats of varnish, you can take the finish to an even lovelier, richer appearance by wet-sanding it, and all these instructions are provided below. Execute each stage carefully so that your creative efforts will be well protected and professional looking.

INSTRUCTIONS: VARNISHING

1. Make certain that the surface of your piece is totally dry. You can ruin a beautiful piece of decorative art if you do not let the piece dry completely before applying a varnish to it.
2. Using a tack cloth, wipe the entire surface (including sides) to remove any dust particles that might have accumulated on the piece. Try to work in a clean, dust-free environment when applying varnish.
3. Stir the varnish very thoroughly to mix all of its components together. Use a wooden paint stirrer for this. You should also periodically stir the varnish as you work to keep it well mixed and ensure a consistent application.
4. Dip the varnish application brush into the varnish. Don't dip it more than half way up the bristles. Let the excess varnish drip into the can, and *don't* stroke or pat the brush against the edges of the can as this can cause air bubbles to form in the bristles.
5. Stroke the varnish onto the surface, trying not to restroke any area too often. (See photo at left.) It is best to apply a thin coat to the surface and *leave it alone*. The more you brush into the varnish, the more likely you are to create bubbles.
6. Let this coat of varnish dry according to the manufacturer's recommendations, and then apply two more coats in the same manner. Pay special attention to the suggested recoat time—the varnish may be dry to the touch hours before you should attempt to apply a second coat. Read the label for this information. Also, wipe the surface with a tack cloth before you apply each subsequent layer.

Stroke the varnish onto your piece using the varnish application brush. To avoid creating bubbles in the varnish, try not to restroke the surface too much.

INSTRUCTIONS: WET SANDING

1. Once the varnish is completely dry, dip a piece of #400 grit sandpaper into some water and drag it across a bar of Ivory soap. The soap will lubricate the sandpaper and help it glide over the surface.
2. Rub the sandpaper over the surface in a circular motion. If the sandpaper becomes dry, dip it in water and rub it on the bar of soap again. Move across the surface, and do not linger in one place too long or you might sand through the varnish to your underlying painting or finish.
3. When you finish sanding the surface, wipe it with a damp cotton rag. This will remove the sanding residue and the soap film. Let this dry.
4. Apply several more coats of varnish in the same manner as before, and wet-sand the surface again. You can apply as many as 12 coats of varnish for an extremely deep and beautiful finish.

Varnishing is an integral part of the decorative painting process; after putting so much effort into creating a beautiful finish, you want it to last, so most small accessories and decorative objects should be varnished. I painted this thermometer/barometer using alligator-style texturizing and then varnished it with a polyurethane varnish to protect it from everyday wear and tear. The colors of the finish (cream for the basecoat and dark brown for the glaze) give the piece a rich, leatherlike quality.

This den floor of heart pine wood was stripped and then stained in a marquetry pattern. A "tumbling block" border follows the shape of the room. After staining, the floor was refinished with a polyurethane varnish, which serves to protect it from foot traffic. The varnish has yellowed over time, giving the floor a mellow, rich, amber feeling.

I finished the background of this floorcloth with green and orange ragging, then applied the central oval and the decorative painting over this. So that they better endure daily foot traffic, floorcloths should be covered with two or three coats of varnish. You can use any of the varnishes mentioned on the previous page, but should keep in mind that they all have different looks and properties. You may want to make tests first on some scrap fabric.

DECORATIVE PAINTING PATTERNS

The use of patterns will make your job of painting decorative designs much easier. If you cannot draw or feel uncomfortable creating your own patterns, the ones provided here can free you from those worries and allow you to concentrate on the actual painting.

I've included several designs, which you can change, and enlarge or reduce as you see fit, and there are several approaches you can take when using these or any other drawing guides and applying them to a surface. My favorite method is to trace my pattern onto tracing paper and then, if it is not the correct size for the piece I'm working on, either enlarge or reduce it on a photocopier. This is by far the easiest and most efficient way to alter the size of a given design.

To accurately achieve the size I want, I use a proportion wheel, which is divided into percentage increments. You can find these at craft and some art supply stores. I measure the design as it is and then the size I want it to be. Then I align these two measurements on the wheel, and it gives me the correct percentage of enlargement or reduction. If you don't have a proportion wheel, you can enlarge or reduce a design several times on a copier to get the size you want.

Once I have the pattern at the right size, I trace it again onto tracing paper using a fine marker or ballpoint pen. I tape it lightly to the surface on which I'm painting and slip a piece of transfer paper under it. You can find transfer paper at drafting or art supply stores. If I am working on a dark background surface, I use white transfer paper; if my surface is light or white, I use gray transfer paper. Once the transfer paper is in place, I trace over the lines once again, checking periodically to be sure that the design is transferring to the surface and that I can easily see it. When I finish transferring the entire pattern, I remove all the paper and begin painting.

Remember to look beyond the designs in this book. There are hundreds of patterns created specifically for decorative painting. You can find images on many things; for example, sometimes a design on a paper napkin or towel is a great starting point. And, don't forget to look at fabrics. You might need to alter the original motifs in order to get a good, workable image, but you can certainly find endless sources of inspiration for further design work.

This symmetrical brushstroke design looks like stylized flowers. You can see this on the front of my planter on the top of page 120.

You can see this pattern on my book box, on page 112, where I also painted a border to encompass the design. I would describe the image as two stylized flowers with large brushstrokes above and below.

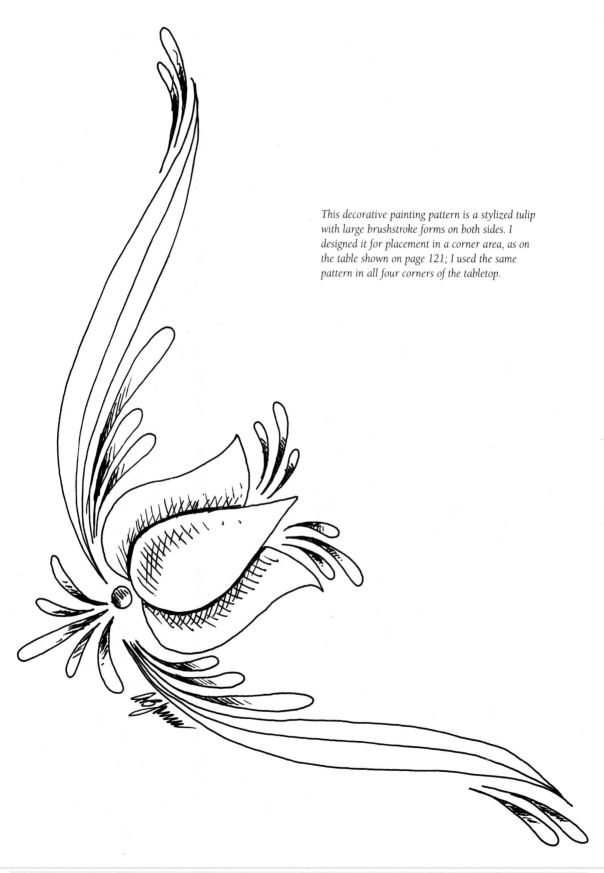

This decorative painting pattern is a stylized tulip with large brushstroke forms on both sides. I designed it for placement in a corner area, as on the table shown on page 121; I used the same pattern in all four corners of the tabletop.

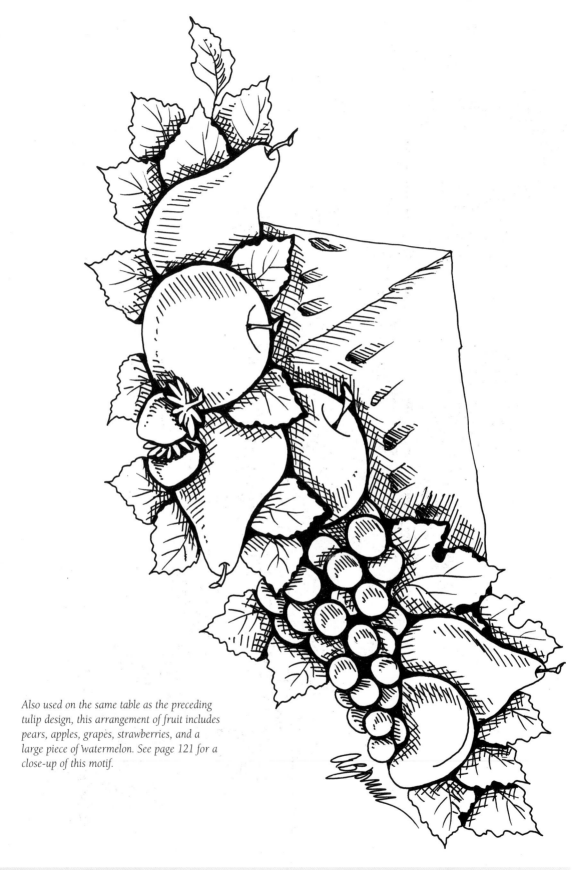

Also used on the same table as the preceding tulip design, this arrangement of fruit includes pears, apples, grapes, strawberries, and a large piece of watermelon. See page 121 for a close-up of this motif.

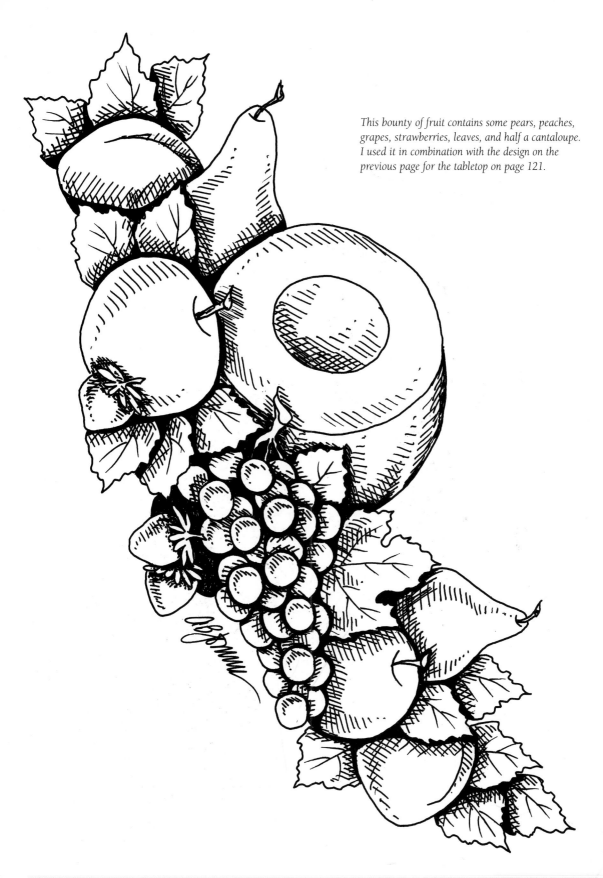

This bounty of fruit contains some pears, peaches, grapes, strawberries, leaves, and half a cantaloupe. I used it in combination with the design on the previous page for the tabletop on page 121.

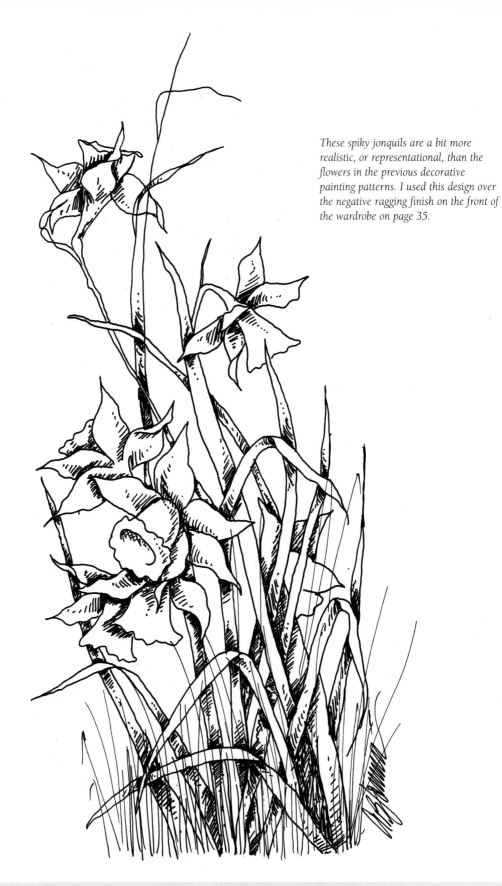

These spiky jonquils are a bit more realistic, or representational, than the flowers in the previous decorative painting patterns. I used this design over the negative ragging finish on the front of the wardrobe on page 35.

You can use these black-eyed Susan patterns as they are placed here, or you can rearrange them any way you like. See my small tavern sign on page 45 for an example.

This rose-in-a-heart gains interest due to the off-center placement of the flower. It was perfect for the heart-shaped box on page 113, but you can also use the rose and leaves on other objects without the heart-shaped outline.

I used these peaches and cherries as a lamp shade decoration (see page 55). The arrangement was perfect for the narrow shape of the shade.

Just like the pattern on the previous page, this realistic pears-and-grapes image would work well on a narrow object, like a lamp shade. Of course, you can also use the design on items of other shapes.

This stylized motif is composed of four flowers surrounded by small, expressive brushstrokes. You can see it on the cover.

These last two patterns do not appear
on any finished pieces in the book, but I
wanted to include them here to give you
additional design options. This single
flower could add a lovely, delicate touch
to any surface.

This is my interpretation of a traditional tulip flower form often seen in Pennsylvania Dutch designs.

Sources

There are far too many sources of artists' supplies to be able to provide an adequate list here. Search your area to see what is available to you locally. Throughout the book, I've included the names of many companies whose products I use on a regular basis. In the event that you cannot find some things, try contacting these stores and manufacturers for materials.

Art Craft Wood Shop
415 East 7th Street
Joplin, MO 64801
(800) 537-2738
Unfinished wooden accessories

Back Street Inc.
3905 Steve Reynolds Boulevard
Norcross, GA 30093
(770) 381-7373
Water-based glazes, foil leaf, water-based varnish, decoupage prints and supplies

Barb Watson's Brushworks
P.O. Box 1467
Moreno Valley, CA 92556
Metal trays

Chroma Acrylics, Inc.
205 Bucky Drive
Lititz, PA 17543
in PA: (717) 626-8866; elsewhere:
(800) 257-8278
Mediums (including crackle medium and acrylic retarder)

Dee-signs, Ltd.
147 Jackson Street
Newnan, GA 30263
(770) 253-6444
Stencils

Gretchen Cagle Publications
403 West 4th Street
Claremore, OK 74018
(918) 342-1080
Decorative painting books, seminars, and videos

Khoury, Inc.
2201 E. Industrial Drive
Iron Mountain, MI 49801
(906) 774-6333
Unfinished furniture

Kingslan Publications
9851 Louis Drive
Omaha, NE 68114
(402) 397-1239
Decorative painting books, seminars

Martin F. Weber Co.
2727 Southampton Road
Philadelphia, PA 19154
(215) 567-5600
Artists' oil and acrylic tube paints

One Heart . . . One Mind
310 North 2nd East
Rexburg, ID 83440
Stencils

PCM Studios
731 Highland Avenue NE, Suite D
Atlanta, GA 30312
(404) 222-0348
Books and videos by mail order; seminars

Priscilla's
P.O. Box 521013
Tulsa, OK 74152
(918) 743-6072
Decorative painting books, seminars

Silver Brush Ltd.
5 Oxford Court
Princeton Junction, NJ 08550
(609) 275-8691
Artists' brushes

Walnut Hollow, Inc.
Route 1
Dodgeville, WI 53533
Unfinished wood surfaces

Whittier Wood Products
3787 West 1st Avenue
P.O. Box 2827
Eugene, OR 07402
Unfinished wooden furniture

Suggested Reading

Andre and Lipe. *Decorative Painting for the Home.* New York: Sterling/Lark, 1994.

Bennell, Jennifer. *Master Strokes: A Practical Guide to Decorative Paint Techniques.* Rockport, Massachusetts: Rockport Publishers, 1991.

Hauser, Priscilla S. *The Priscilla Hauser Book of Tole and Decorative Painting.* New York: Van Nostrand Reinhold, 1977.

Hunt, Peter. *Peter Hunt's How to Do It Book.* New York: Prentice-Hall, 1952.

Myer, Phillip C. *Creative Paint Finishes for the Home.* Cincinnati: North Light Books, 1992.

O'Neil, Isabel. *The Art of the Painted Finish for Furniture & Decoration.* New York: William Morrow & Company, 1971.

Ridley, Jessica. *Finishing Touches: A Do-It-Yourself Guide to the Art of the Painted Finish.* New York: Charles Scribner's Sons, 1988.

Shaw, Jackie. *The Big Book of Decorative Painting.* New York: Watson-Guptill Publications, 1994.

Sloan, Annie, and Kate Gwynn. *Classic Paints and Faux Finishes: How to Use Natural Materials and Authentic Techniques in Today's Decorating.* New York: Reader's Digest, 1993.

Sloan, Annie, and Kate Gwynn. *The Complete Book of Decorative Paint Techniques.* New York: Portland House, 1989.

Credits

Page 8 (bottom middle): Photo courtesy of the Decorative Arts Collection, Newton, KS.

Page 39 (middle): Finishes and interior design by Andy B. Jones and Phillip C. Myer.

Page 39 (bottom): Photography by David Schilling. Finishes by Andy B. Jones and Phillip C. Myer.

Page 99 (bottom right): Decoupage projects by Andy B. Jones and Phillip C. Myer.

Page 113 (bottom): Photography by David E. McCord. Painting by Andy B. Jones and Phillip C. Myer.

Page 125 (bottom left): Photography by Andy B. Jones. Finish by Andy B. Jones and Phillip C. Myer. Interior design by R. Carter Arnest.

Page 125 (bottom right): Floorcloth by Andy B. Jones and Phillip C. Myer.

Index